Po
Emerge

Iona E. Locke

Poised To Emerge
© Iona E. Locke 2017

ACKNOWLEDGEMENTS

My deepest love and appreciation is extended to Abyssinia Christ Centered Ministries for your unrelenting support, your faithfulness in service and your devotion to worship. For over 23 years you have walked in faith with the vision that God has established for our house. Your gifts have been used unsparingly to demonstrate in small detail and great fashion, what God has willed us to do. As your pastor, I am humbled by your insistence on walking me through dark valleys and pushing me to mountaintops. You are the beat of my heart.

To Christ Centered Ministries Assembly over which I serve as presiding prelate: no words are adequate to express my profound gratitude to you for the faith and fearlessness that you have confirmed in our association. May God forever be glorified in each and all of us.

I am so grateful for my sisters and friends who have struggled for equality and respect in the ministry. What we have worked for independently will come forth as we come together. I thank you for your encouragement and support over the years.

I also thank the many brothers who have stood for right against cultural reason and have not denied the power of God in women to preach, teach and lead in the Body of Christ. Because of you, the entire church stands poised to emerge.

Preface

Called into the ministry at an early age, Iona E. Locke,
D.D., Th.D., though gifted, anointed and with an obvious love
for the Lord, suffered at the hands of some men who would
teach, preach and practice that even women with her enormous
gifts were limited by their gender and not expected to succeed
in what is still perceived as a *man's world.* After becoming a
world-renowned evangelist, she served other leaders in various
churches until 1994 when God called her to found and pastor,
Abyssinia Christ Centered Ministries. In obedience to the call
of God, Dr. Locke stepped out on faith to birth the
ecclesiastical alliance, Christ Centered Ministries Assembly,
over which she was consecrated bishop in 2001. Her elevation
to pastor and then to the bishopric was not met with a chorus of
approval. Many who applauded her gifting as an evangelist
could not receive her as a pastor and fewer, even, as bishop.

Because of the struggles of female leadership in
Christendom, Bishop Locke's regular dialogue with God
included a desire to see herself more in His body. Why would
He have called so few women to lead what is in essence a

predominately female assemblage? Why would only 20% of the population (male) be given the rule and government of 80% irrespective of the knowledge, talent, gifts and anointing that rested in the overwhelming majority? Why would the chosen (female) few, to whom He had entrusted the shepherding of His flock, not succeed in the numbers that she had witnessed in male-led churches? For how long would women struggle with insufficient resources and strain to bring into fruition the dreams and visions that He had seeded in them?

As is often God's nature, questions are met with directives and challenges that appear greater than one's original calling. In this case, Bishop Locke was instructed by God to take on an extraordinary project that would bring together women pastors from throughout the country, that through their unity and bonding they might be encouraged and empowered to emerge, from what appeared to confine them, to assume the more visible and active roles that are both deserving and needed. Imago Productions is the direct result of her obedience to God and her search for the mirror images that she has needed in her own life. It serves to *reveal* the work of women in the office of pastor and the enormous contributions they are making nationwide; to *revive* the zeal and fire in those who have

become disheartened by the struggle of their existence and to *resurrect* in all women throughout the world, their knowledge of who they are in God and their full rights to serve Him in whatever capacity they have been called.

Poised To Emerge, originally the title of Bishop Locke's doctoral dissertation, offers insight to the struggle over gender apartheid from a perspective of those who were held hostage by tradition and institutionalized sexism, which yet have strongholds over religious practices today. It will provide inspiration to those going through the process of evolution from fear to freedom and it will inform others who stand watching the struggle that any system that holds a group of people to less than their capacity for full involvement and contribution, holds the entire body at less than its ability to produce.

<div style="text-align: right">

Overseer Belinda Ashford-Walton
Adjutant Apostolic to Bishop Locke

</div>

Introduction
The Painted Lady

In the process of developing the outline from which this book would be written, God showed me a picture of a butterfly hanging in its pupa. As I further studied the meaning of this image, I was astounded at the stages of the metamorphosis of this tiny creation of God and its comparative analogy to women and their development within the body of Christ. As an African American woman, it was striking for me to note that the particular butterfly that I studied, *The Painted Lady,* had its origin in North Africa. [1] Her four stages of development are described in popular terms as the egg, caterpillar, chrysalis and adult or butterfly. A more scientific language favors ovum, larva, pupa and imago, but frequently the two sets of terminology are interchanged.[2] For the purpose of this publication, I will use both as I describe in vivid terms, the growth process, or lack thereof, of women in the church of our Lord Jesus Christ.

Divided in four parts that I have labeled in direct correlation to the metamorphosis of the butterfly, I have written the historical view of women and their attempts to secure equality in western civilization and in the Church. I have

discussed the basis of scriptural contest from the male perspective as to why there are inferior roles or positions to which women have been relegated for centuries. I challenge those positions based on the contextual and cultural events from which they were extrapolated. And I offer to women a call and a charge to control the spiritual transmutation of their lives. Although my desire is to inspire *all* women through this book, it is specifically written to those who have heard the call of God to be preachers and teachers of His Word as pastors and shepherds of His flock. It is to these who struggle with the hostility of sexist attitudes and twisted interpretation of scripture, that I dedicate the focus of my efforts. It is to this band of women, embattled and scarred through warfare and wrestling, that I challenge to stand in commanding fashion, the place wherein they have been called by God.

We have seen the Body of Christ grow in extraordinary numbers and have witnessed the rise of mega churches as never before. Although women fill the pews of these churches by the thousands, we have also seen the typical disproportionate number of women in leadership positions and fewer even as pastors. Because of this, the Church, though seemingly prosperous, is weakened by its insistence on holding onto

tradition and institutionalized sexist practices rather than allowing women to be fully free to use their gifts for the betterment of the Body and to the glory of God. But there cometh a new horizon, where God has called forth His women to seek freedom, not through permission, but through perseverance. He is building in them the fortitude to break through the stained glass ceilings so that His glory in them can break forth. But to do so, we must ensure that our own development is complete by securing the maturation process that will make us whole. As we stand on the precipice of our finest hour, hanging between prejudice and promise, we are indeed poised to emerge as victors. But we must walk the painful road from ovum to imago that we, and therefore the Church, might *come forth as pure gold.*

Table of Contents

Ovum

The Painted Lady, *Vanessa cardui*, begins her metamorphosis or life cycle - like that of most sexually reproducing organisms - as an egg. Butterfly eggs can vary greatly in size, shape and color. Some are almost invisible to the human eye. Butterflies are either born with their full complement of mature eggs or the eggs mature gradually inside them. The Butterfly egg is generally laid on a leaf or food plant that will serve to sustain it once it has reached its next stage as the caterpillar. There is some evidence that some butterfly females have a preference for laying eggs on food plants that they themselves grew up on when they were caterpillars. Eggs risk being eaten by true bugs and being parasitized by hymenopterous egg parasites. They are laid singly or in groups and are packed with nutrients or laced with deterrent poisons. Because the continued existence of the butterfly is contingent upon the survival of its eggs, the strategy in most species is to produce eggs which are concealed from predators and parasites. Eggs may be laid on either the upper or lower surface of the leaf. Below the leaf the eggs are less liable to be damaged by sunlight and are out of the gaze of predators.[3]

Chapter One
The First Victim of Power

The history of women in western civilization, and indeed in the entire world, is one that is birthed and bathed in struggle. There is no other single group of individuals who have suffered the ignominious treatment that we have and continued to survive and thrive. Yes, there have been those minority groups, including our own, African Americans, that have come through great struggle for equality and yet fight for the right to fair and equitable resources that we might enjoy the same benefits to life in a free society as do our White counterparts. However, even within our community, the degree of struggle and suffering is divided by gender and the doors that are opened to our men often remain closed to us. As a group, we (African American women) are required to deal with the dual tendrils of racism and sexism that are offspring of the same demonic spirit of oppression. It is through our history as women and as African Americans that the relationship between the two are exposed. I will further reveal the vile confluence of racism and sexism as I continue the discourse here. I will also demonstrate how both have scarred the body of Christ and left it limping in fetters of ignorance and intolerance, thus being a shell of what

it was intended to be.

When And Where We Enter

The history of the United States is not one that is kind to any group of people that is not Caucasian and male. The plight of the original inhabitants of this land, the Native American, is an ongoing saga of oppression and disentitlement. The savagery of slavery has been well documented and its affects are yet manifested in the minds and actions of both its victims and perpetrators. Both (male) Native Americans and African Americans, who make up the largest independent groups of mishandled minorities have made gains, especially in certain arenas, that women, collectively and in particular, African American women, have yet to experience or enjoy.

During the early U.S. history, women could not vote, sit on a jury or run for political office. Any property that she brought into a marriage fell under her husband's control. She was not entitled to keep money she made working outside of her home. Very few girls received a thorough education and no colleges would admit female students.[4]

Married women were restricted by the legal concept of coverture, which stated that a wife's legal identity and rights

2

were subsumed by her husband. In the case of her husband's death, she had no automatic right to her own children. She could not buy and sell property, sign contracts or make a will without her husband's consent. While single women were not bound by coverture and theoretically had more rights, in practice they were often required to turn over their earnings and control of their legal affairs to their male relatives.[5]

Although as early as the colonial days, some individual Americans - both men and women - raised questions concerning the unequal status of women, a concentrated movement did not being until 1848, when the first convention on women's rights was held at Seneca Falls, NY. This new movement for women's rights focused on a number of issues, including married women's property rights, equal pay for working women, liberalized divorce laws, dress reform, and education. Suffrage - the right to vote - was one of the first and foremost demands of the movement.[6]

I will not equivocate, I will not excuse, I will not retreat a single inch - and I WILL BE HEARD! From The Liberator, *an abolitionist weekly by William Lloyd Garrison*

The importance of the Suffrage movement to women and their search for equal rights lay in the fact that it gave them a voice. The laws of the country had forced them to live in silence and therefore allowed them to be discounted as insignificant. Without a voice and a means of impacting what was happening around and to them, they were prey to the men that would use them solely for their benefit and to their discretion. Securing the right to vote was considered a radical move and too extreme, and thus, even those women who would argue for other rights felt that the push to vote was asking for too much. Oddly enough, it was Frederick Douglass, a former slave who understood too well the life of silent, disenfranchised living, who became the first man to support and defend women's right to vote,[7] a privilege he would never come to know for himself. When some women would argue that the right to vote be dropped from the platform of the women's rights convention, it was Douglass that urged them to fight for this right as an important means of changing the laws that would affect the lives and freedom of all women. It was

apropos that Douglass would take such a stand and involve himself so passionately in this campaign, for it was White women who joined and formed Anti- Slavery Societies that also goaded the work and growth of the abolitionist movement in the United States of America.

Women being heard represented some deterioration of a man's power over them and therefore, a quiet woman, who spoke only with the consent of her husband became the paradigm of the woman that (male) society would acknowledge and respect. Women were expected to follow strict social rules: They were to cultivate a modest and docile personality, center their lives around their children and domestic tasks, and obey their husbands in all matters. Furthermore, women were not allowed a public voice: Most churches and other social institutions forbade women from speaking during services or meetings, and women were not supposed to publicly air their opinions on the important issues of the day. It was not until the 19th century that discontent over the women's situation reached the boiling point, and one of the main irritants was that women could not speak publicly.[8] As author Miriam Gurko explains, "In the early nineteenth century, women simply did not address a public group. It was considered not only beyond their

capacities, but was frowned upon as improper, indecorous, unfeminine, irreligious, against both God and nature."[9] It was bad enough for a woman to go on a lecture tour and speak in public auditoriums to other women, but it was unheard of for a woman to address a *mixed* or *promiscuous* audience of both men and women. Nevertheless, a handful of abolitionists women began to do just that. Two, who created the most commotion were Sarah and Angelina Grimke, the daughters of slave owners in South Carolina. Becoming Quakers, they moved to the north and joined the Anti-Slavery movement. Initially, they spoke before small groups of women, but their lectures attracted overwhelming crowds and many men began attending to where they were addressing large mixed audiences everywhere. In July 1837, Angelina even publicly engaged in a debate with two men. They were roundly condemned as immoral.[10]

The Gimke sisters began to draw a parallel between slavery and the status of women. In her *Letters to Catherine Beecher,* Angelina Gimke wrote, "the investigation of the rights of a slave has led me to a better understanding of my own.....Woman was....the first victim of power. In all heathen nations she has been the slave of man and Christian nations

6

have never acknowledged her rights." [11]

Chapter Two
A Cry for Change

It is both surprising and disappointing to note that the changes in the attitude and demeanor of our nation and world regarding women have been minimal if one would judge this change by the treatment that we receive at the hand of those in power. We saw and continue to see just how important the voice of the vote was to us, as it gave us the tool by which we could affect change. Despite the arduous tasks of working endlessly for suffrage, Elizabeth Cady Stanton and Susan B. Anthony, founders and foremost members of this movement, failed to realize the victory in their lifetime. Of the 68 women at the Seneca Falls Convention for Women's Rights, who signed the resolution for suffrage, only one - Charlotte Woodward, then 19 years old, lived to see passage of the constitutional amendment in 1920.[12] For nearly a century, from the 1848 Convention until August 26, 1920, women fought for a vote, a voice, so that they could speak for themselves and ensure that laws could and would be passed that would have their best interests in mind. Their goal was simple, yet profound in its impact on society: They sought enfranchisement and

political equality for half the citizens of the U.S.[13]

How is it, one *must* ask, that comfort can be found in a minority rule over a vast majority, without regard to the decent treatment of that minority group? How can you ignore the gifts and talent that lay in a group of people simply because you desire to have power over them? In looking at not only our U.S. history, but that of the entire world, we can see that this is an offense that has been perpetrated for generations. In South Africa, White Africans, a small minority of the country's population, governed that country and lived in prosperity, while the vast majority of Black and Colored Africans served them and lived in squalor. In India, millions suffered under British rule and lived impoverished lives while the British enjoyed the freedom of free and comfortable living. To achieve this kind of domination a mental conditioning must take place in both parties. It is something that is common to anyone who enslaves another or demonstrates a force of power that goes unchecked and unanswered. The group in power must get the *lesser* party to 1) Respect them; 2) Fear them; and 3) Depend on them.[14] This list came from another author, but I would add a fourth thing that must be done and that is to *ensure that they remain silent.*

Power concedes nothing without a demand. It never did and it never will.
Frederick Douglass

History and the Word of God offer documentation that a voice, a cry, had to be heard before change would come about. The situation or circumstance, alone, was not enough for change to occur. There had to be a demand for that change and it needed to be voiced. For 430 years the Israelites dwelt in the land of Egypt. After suffering the oppression of the Egyptians, they cried out to the Lord and He heard their groaning and sent Moses, their deliverer.[15] In South Africa, Nelson Mandela lent his voice to the oppression of his people and through prison bars cried for his nation to change. That cry was heard throughout the world and apartheid had to fall to the resounding demand that injustice would not be tolerated. In India, Mahatma Gandhi, with soft-spoken gentleness, helped his country see that they could demand to be treated decently and that they could control their own destiny. In America, with the eloquence and power of speech that his righteous indignation afforded him, Dr. Martin Luther King, Jr., sounded forth not only the despicable conditions of his people, but demanded that *we would be free some day.*

10

With every cry and call for change there is a demand for sacrifice by those who would lift their voices. As in the case of Elizabeth Cady Stanton and Susan B. Anthony, they failed to see the result of their diligence in being able to cast a single vote. But they died knowing that their work was not in vain. For Nelson Mandela, his voice cost him almost thirty years of imprisonment. For Gandhi and King, the price was their deaths. But if former Surgeon General Dr. Jocelyn Elders is correct when she states that *the day you see the truth, and cease to speak the truth, is the day you begin to die,* then death through silence is a more costly demise and it is one to which this author will not succumb. With full recognition that there will be harsh criticism and character assassinations, I am crying with a call to change. With the revelation that there will be those women who will retreat and seek to stay in an embryonic state, vulnerable to the parasitic forces that govern them, I cry with a call to change. With a love for God and a deep passion for His church and a desire to see it in a more glorious state, I cry with a call to change. Whatever the sacrifice, whatever the cost, I, too, believe that *we shall be free one day.*

Chapter Three
The Problem With Women

Throughout history the culture and traditions of the time have always been reflected in the Church. Purists have tried to insist that the Body of Christ stand alone and independent from worldly influences, but the truth is that that has never occurred. It is this very fact that lay at the core of the debate over *controversial* scriptures that supposedly define the role of women in Christ's church. The reflection of Jewish mores and tradition in the Holy Scripture must be acknowledged in light of the texts that are typically used to shape the minds of men towards women, women towards themselves and their accepted role in the Church.

There is a method of study that Bible scholars are encouraged to use that is referred to as HGC. They should consider Historical information, including the time, place and cultural conditions surrounding the writing, the Grammatical structure of the passage in the original language and the Contextual evaluation of the passage, comparing it with other Scripture and writings to understand how certain words and phrases were used elsewhere.[16] Unfortunately, when discussing

the issue of women and in particular, Paul's teachings referencing them, many men would abandon the scholarly method of HGC.

The Theory of Inerrancy

Neal Jones states that *the Bible is the Word of God, written in human words. To be human means, among other things, to be situated in a particular time and place. However insulting to our pride this may be, the fact remains that every person is a particular, relative, dependent, fallible, finite creature. Fundamentalists deny the particularity and hence the humanity - of the Biblical writers by imposing on Scripture their theory of inerrancy. Inerrancy crystallizes relative cultural, historical, and ethnic conditions into timeless, universal standards.*[17] Thus inerrantists believe that culture and history have no special bearing on how Scripture should be interpreted, imposing upon those they teach, a literal translation of the Word of God. The problem with this, however, is that it is never done consistently. What one will find is that it is only applied with those texts that refer to women and their submission to men. This fact has led Jones to assert that the problem that inerrantists have is not with the role of women or with their elevation (as in ordination) but

13

it is with women themselves.[18] This premise is also supported

by the Rev. Joan Brown Campbell, the General Secretary of the

National Council of Churches, who says, *the prejudice against*

women doesn't end with ordination. For she found that many

women ordained as Protestant clergy find that they are hired as

Assistant or Associate Pastor but are not promoted to senior

positions.[19] There is simply a problem with women.

> *Praise be to God He has not created me a Gentile; praise*
> *be to God that He has not created me a woman; praise be to*
> *God that He has not created me an ignorant man. Tosephta*
> *Berakhoth[20]*

All Jewish men prayed a daily thanksgiving which

described their opinion of women. For one of the gravest insults

was to call a Jewish man a gentile, a slave, or a fool. By

equating women with these groups, they were showing what

was in their hearts. They thanked God daily for not being

women. Though this opinion of women was taught as if it was

supported by the teachings of the Torah, the law, they were

rather based on traditions and teachings that were passed down

from one generation to another until they formed an oral law of

the Jews. Those laws are now called the Talmud, an Aramaic

word meaning *learning.* These teachings and traditions

gradually became law, halacha, and were accepted to be as authoritative as the written Word.[22]

In the days of the writing of the New Testament, the Jewish culture and treatment of women was and is common knowledge. Under Jewish law, husbands could divorce their wives for any cause but wives could not divorce their husbands. Wives were chattel. Polygamy was tolerated. Women were considered inferior to men in every way, and less intelligent. They were also considered spiritually inferior. Women were not allowed in the Temple and were not counted among the ten Jews necessary to start a synagogue. At the coming of Christ, rabbinical schools were still debating whether women actually had souls. Generally, the attitude toward women was one of disregard, subjugation and repression.[24] A rabbinical statement to reflect these attitudes was: *When a boy comes into the world, peace comes into the world; when a girl comes, nothing comes.*[25]

The Truth Behind the Teaching

To suggest that this halacha, these traditions and schools of thought had no influence on the practices of the early church is at best naive thinking. Society dictated how women were

treated and regarded in the temple, just as it (society) is reflected in our churches today. Therefore, scholars uniformly agree in their discourse on those Pauline letters that would suggest his supporting sexism and the oppression of women in the modern day church, that the accepted cultural trends of his day, the *halacha,* had to be considered to understand the truth behind his teaching.

It is not my desire to deal with an in depth discourse of the defense of those *controversial* texts (I Cor. 14:34-35; I Cor. 11:2-13; I Tim 2:11-12) where Paul seemingly places women in subjection to all men and does not allow her to even speak in their presence. For we know that historians, scholars and most men and women of the clergy, except for the strictest conservative denominations, believe these texts to have a limited teaching regarding a woman and do not take a literal translation of the text requiring women *to be silent.* (I Cor. 14:34) It is safe to say that all churches do allow women to sing and pray in the worship service though some, only permit it to be done jointly with men. However, my desire is to go beyond those who have in their minds *settled their women problem* by allowing them to usher, lead choirs and even serve as elders and associate and assistant pastors. These churches do not use

those *controversial* texts to argue for complete silence of the woman, in part because in many instances due to their size and limited male population they would not be able to enjoin themselves in worship if it was restricted only to male participation. Therefore they have accepted some limited form of truth behind Paul's teachings so as to support their mere survival as a church. However, it is my desire to challenge those who through convenience and personal comfort have used God's Word as a prop for their existence as I endeavor to uncover the *whole truth and nothing but the truth...so help me God.*

From the cowardice that shrinks from new truth, from the laziness that is content with half-truths, from the arrogance that thinks it knows all truth, O God of truth, deliver us. An Ancient Prayer[26]

Chapter Four
Sin That Silences

In August and September of 2001, the United Nations held a World Conference Against Racism in Durban, South Africa, and it was boycotted by the United States. It was disappointing to many citizens of this country as well as those around the world, that the most powerful and influential country on the globe would choose to be silent through its absence, on one of the most problematic subjects that persists within its borders. Since the days of slavery, racism has been a scourge in this land, forever separating its citizens through acts of discrimination, both openly and covertly, that reminded us daily that we are all considered equal in principle but certainly not in practice. There has not been a single place or institution in America that has not been affected by the demon of racism. And that includes our churches. In fact, Sunday morning has often been called *the most segregated hour in America*. For it is then that the cultural practices of our society are reflected in our worship. For decades Whites worshipped with Whites and African Americans worshipped with African Americans and few ever said a word about it. We allowed ourselves to be silent about this sin because in many ways it served us well. After all,

society was so entrenched in its racist practices and did not give the African American male the opportunities that it gave its White counterpart. Therefore, the Black Church provided him with validation, self-esteem, confidence and the chance to lead - things denied to him in the work place. Unfortunately for the African American female, it (church) gave him position and power regardless of his abilities, because it had determined that it would undo the wrongs of society, even at her expense.

Due to the exposure of racism's ugly practices we have seen more churches blending with concentrated effort to bridge the separatism that engulfs the Body of Christ. As time progressed, voices emanated from within the Body that decried the practices as ungodly, embarrassing to the effort to disciple and finally as sin. However, for years as the Church allowed the culture of the times to dictate its practices, it used Scripture to support its silence against the egregious offenses and injustices that prevailed within its Body. Therefore, it misused the Word of God to justify its silence against sin. One author, Floyd Rose, noted that the same has occurred in its treatment of women: *During slavery, Whites didn't read the Bible first and discover that they had to enslave Blacks. They enslaved Blacks and then went to the Bible to find justification for slavery.*

Similarly, men through the years dominated and exploited women, assigned them a place in the church that was separate, apart and inferior, and then looked for scriptures in the Bible to justify their domination.[27] Stanley J. Grenz and Denise Muir Kjesbo agree....throughout history people have twisted the meaning of Scripture to support their own questionable positions on particular issues. The question of women in leadership is no exception to this tendency.[28]

One Demon - Two Heads

Few sane people would continue to try to justify something so ugly as racism and the practice of separatism in the worship service. But many would and do use Scripture to justify sexism and the inferior treatment of women. They call the scriptures *controversial* because they have been argued so fiercely over the years that they have begun to divide the Church. The use of this word also allows some to maintain their opinions and hold onto societal practices even when those practices cannot be supported by rightly dividing the *entire* Word of God. They are decidedly blind to this being the same demonic spirit, with two heads. The same African American men who now preach fervently against racism and who have taken extraordinary

means to integrate their churches, even at the point of sharing their power, remain silent to the oppression of women. Caucasian men, who risk their standing within their communities to declare an open war on racism, and who have opened their churches and pulpits to African American men and others to demonstrate their heart felt desire to put an ugly past behind them, remain silent to the repression and discrimination of women. It has become obvious that in the same manner in which the world had to embarrass and lead the Church out of its racist practices, it will have to do the same to bring about an end to sexism as well. The Body that God designed to influence and change the world waits for the world to influence and change it. Godly men, through silence, have boycotted the effort to set erect the Church for which Christ died, and have allowed a moral crisis to fester and threaten its very existence. Their silence has granted them the privilege of passivity and the opportunity to hide behind the skirt of neutrality. But this ostrich approach will not allow them to be blameless and to wash their hands of the blood lost in the struggle for equality and justice in the Church. Silence and neutrality comes with a price and it may be one that they dare not desire to pay. For Dante has said that *the hottest places in hell are reserved for*

21

those who in a time of moral crises, maintain their neutrality.

A Tragic Misconception of Time

While in a Birmingham jail cell, the Rev. Dr. Martin Luther King, Jr., received a letter from a White Christian in Texas which said: All Christians know that the colored people will receive equal rights eventually, but it is possible that you are in too great of a religious hurry. It has taken Christianity almost two thousand years to accomplish what it has. The teachings of Christ take time to come to earth. In sharing these words with his fellow clergymen, Dr. King avowed that this statement represented a tragic misconception of time. He concluded that the people of ill will used time much more effectively than the people of good will. He then added that we will have to repent in this generation not merely for the vitriolic words and actions of the bad people, but for the appalling silence of the good people.[29]

I'm sure that many would suggest to women in the Body of Christ that we are *in too great of a religious hurry* regarding our need and desire for the end of the sexist ideology that permeates the Church. But that suggestion, too, would represent a tragic misconception of time. We cannot procrastinate, hesitate or vacillate... we simply do not have the time. We cannot allow ourselves to be lulled to sleep by the apathy of our brothers who prefer silence to speaking and sitting to standing...we simply do not have the time. Though their silence is appalling, it is deafening and it serves to remind us that with haste we had better be about the transformation of Christ's Church in anticipation of His return. We're living in the moment and we simply *do not have the time.*

Chapter Five
Waiting To Exhale

Every group of people, outside of the majority, who have desired to achieve or acquire something in American culture, have been told by those in power to *wait for their time*. They have been put on a time schedule that is created in the minds of those who feel arrogant enough to determine who will do what when, as if they, instead of God, hold time captive in their hands. Therefore, like the misguided writer of the letter to Dr. King, they can use words like *eventually, one day,* and *in time* with a cavalier posture, content to withhold from others that which often is inherently theirs. If time really were up to our own control and choosing then perhaps we would have the patience to sit and wait for others to get tired so that we could then step up and do what it is that God has given us to do. If time would really stand still at our dictate and pause so that our talents and gifts would remain sharp and unabated through the lack of use, then perhaps we could hold our collective breath and wait to exhale. But no man, or woman, controls time.

Undeveloped Potential

One of the greatest tragedies that result in women not being

allowed the free use of their gifts in the Body of Christ is the undeveloped potential that exists. In our determining that only certain people will be allowed to do certain things, we have chosen to deny, and therefore waste, what God has seeded in them. And there are few things more frustrating than unrealized, unfulfilled, undeveloped potential. The very word, potential, represents that which is possible. It evokes dreams of what can become in spite of what we see. It speaks to that which is latent, sitting, waiting to emerge to a fuller state or position. It conjures up thoughts of hope and promise. One cannot look at women in Christ's church and not think, see, or imagine potential. We represent that which both inspires and saddens. We are the hope and the heartache of the Lord's Body. We *are* undeveloped potential.

A Promise Fulfilled... Then Denied

But more than potential, we represent the very promise of God. From the beginning He created us in His image, after His likeness and gave us (women *and* men) dominion over everything on earth.[30] He promised to pour His Spirit upon us to enable and empower us to prophesy[31] and He fulfilled His promise centuries ago.[32] But man, in his own authority, has

decided and decreed through erroneous teaching that this promise should be denied. In doing so he has placed himself in a precarious position, attempting to tie God's hands and limit His power to that which lay only in him. In this, he has elevated himself to God's seat and it is a place wherein he has no authority to sit.

It has never been God's intent that anyone beside Himself would determine the possibilities of His people. Because He is a God who is not limited to man's thinking[33] nor tied to man's limitations,[34] His desire is that we see ourselves in His possibilities and base our lives on that faith and trust.

It is also His desire that we increase that which He has seeded into us through development and use. The example is given by Jesus of the taskmaster who grants talents to his workers according to their abilities. He goes away for a while and returns to see how they have invested or increased the money that he has entrusted to them. To those who have used theirs wisely, he gives more. To the one who through fear has instead hidden his and not developed it, he is scornful.[35] The talents in this parable can represent any kind of resource we are given. God gives us time, gifts, and other resources according to our abilities, and He expects us to invest them wisely until

He returns.[36] It must be noted that the responsibility for the development of the talents lay only in the hands of the person to which they were granted. He gave them according to their abilities and His expectation of their usage was based on that ability. In each situation He knew of their potential to produce.

How then can women afford to allow someone else to determine how we will use or develop what God has placed in us? Knowing the responsibility that we have to do and become what God has promised, how is it that we must ask permission or seek validation for doing what ought to come natural for someone or something in which God has placed His seed? When an egg is laid it goes through a natural gestation process that is contingent upon that which is in it. Its environment, if dangerous and unhealthy to its full development, can cause it to be born deformed, but that environment would have to invade the egg before it is successful in creating a distortion of what the egg would normally produce. The development and progress of women in ministry has been stunted because during our periods of gestation and vulnerability, we have been invaded by poisonous teachings, forces, that have either aborted our seed or caused its malformation. In this state, we have feebly and faintly gasped for air so that we might survive the

27

intrusion of our birth. And having breathed in just enough air of knowledge and truth to secure our continued existence, we must in freedom and not fear, exhale so that the entire Body might live as well.

Women with the apostolic calling must ascend to the bishopric that they might exhale the churches that need to be birthed at their hands. Sisters with the prophetic anointing must breathe forth what *thus saith the Lord,* that the world might be assured of His presence in the land and the church might hear His mandates. Ladies, whose steps are ordered as evangelists must preach fearlessly throughout the world that they might respire a living Word to a dying nation. Females must command their positions as pastors with the authority of their calling, so that as shepherds they might secure the lifeline of their sheep. Mothers, with the wisdom of age and experience, must teach their testimonies and share their triumphs that the church, which lay lifeless before them, might inhale the sagacity of their lives and yet live. Leaders who would withhold from her the cells that would provide nourishment and sustenance have weakened the church of our Lord and Savior Jesus Christ. And in her state of fragility, with ventilator in place, women, the bloodline and breath of the Body, can no

longer wait to exhale.

Chapter Six
Wanting To Explode

What happens to a dream deferred?
Does it dry up like a raisin in the sun?
Or fester like a sore and then run?
Does it stink like rotten meat?
Or crust and sugar over - like a syrupy sweet?
Maybe it just sags like a heavy load.
Or does it explode?
Langston Hughes

The great poet and writer Langston Hughes could have also asked, *what happens to promise postponed? Or potential denied and prevented?* They, too, respond in ways similar to deferred dreams: They dry up, they stink, they sag and they explode.

The single fallacy in the oppression of women and the denial of their equality in service to the Lord's church is the thought that it is not far reaching and that it does not affect and impact anyone but the individual women who are held back through solitary acts of vicious attacks or schemes to control. This philosophy cannot be considered as meritorious in light of Scripture that clearly speak of the relationship of members in the Body of Christ. *For because of Him the whole body (the church, in all its various parts), closely joined and firmly knit together by the joints and ligaments with which it is supplied, when each part [with power adapted to its need] is working properly [in all its functions], grows to full maturity, building*

itself up in love. This amplified version of this text illustrates clearer than most the importance of each person, regardless of sex. Perhaps the most telling part of this scripture states that *when each part is working properly, (it) grows to full maturity.* When women are denied full access to ministry of the Church, every part is not working properly. When women are made to be second-class citizens in the Body of Christ, it will not grow to full maturity. There is a weak link in the Body, created at the discretion of men, causing it not to be firmly linked together because a selective process has prohibited *the church and all its various parts* coming together so that the Body might fitly be joined as one.

The overwhelming problem that I have with this issue is the obvious need for women in the church. Male pastors would be considered far less than intelligent if they would say that women are insignificant to their work. The thought of churches without women is an inconceivable one, and few, if any, would desire that. The challenge to our thinking is not the mere presence of women, but the position of women. Most men who preach that we are a Body that is *fitly joined together and compacted by that which every joint supplieth,* simply believe that women represent a lesser joint and have limited that which we should supply. There is no question that we should supply money. There is no question that we should head kitchen committees, serve on usher boards or prepare for communion and baptisms. We are considered the primary joint to supply

those needs. For it is expected that we feed the bodies of the church. It is prohibited that we feed their souls.

A Single Garment of Destiny

Understanding all too well the interrelatedness of all people, Dr. Martin Luther King, Jr. preached that *injustice anywhere is a threat to justice everywhere. We are caught in an inescapable network of mutuality, tied in a single garment of destiny. Whatever affects one directly affects all indirectly.*[3]* This statement, made in reference to the relationship of races in America, could easily speak to the relationship of the church. Woven together by the blood of Christ, held together by a mandate of discipleship, our aim and purpose should be solitary. For our bloodline ensures that whatever affects one directly affects all indirectly. Therefore the silent frustration of the women who are shunned and overlooked should be felt by the men who need their gifts. The choked voices of the sisters who would cry for respect to complement their responsibilities should be strengthened by the bellow of men who must insist that their voices be heard. Our single garment of destiny demands it.

Limiting the Link.. .Reducing the Power

On September 6, 2001, the City of Grand Rapids dedicated a downtown park in the name of Rosa Parks. Created and designed by New York artist and architect Maya Lin, it

32

represents both the serenity and strength of the woman after which it was named. However, the *Rosa Parks Circle* was almost not so named because in a vote by the Grand Rapids City Commission, not everyone agreed with the idea because they felt that Parks *doesn't have a close link to Grand Rapids?*[9] Upon reading that one would wonder if they had a bus transit system in Grand Rapids that was not segregated by race. One must inquire if they had any public transportation that permitted all races to enter the front door and sit wherever they chose. If so, and I'm sure that they do, then Rosa Parks, through history and sacrifice is linked to Grand Rapids.

This incident speaks to the error of the effort to diminish or limit the link in our relationship with one another. To think that Rosa Parks was not linked to Grand Rapids because she lives in Detroit is to limit her contribution to our great nation to the location of her residence, when indeed the entire country was impacted by her life. In 1955, when she took her seat in Montgomery, Alabama, she stood tall in California, Michigan, Illinois and all over the United States. When we determine to limit our link to a level of our own comfort or thinking, we reduce the power that our association with one another affords.

The amplified text of Ephesians 4:16 says ... *when each part [with power adapted to its need] is working properly [in all its functions], grows to full maturity, building itself up in love.* The power that we need in the Body of Christ comes in

part because of our being knitted together as one. We are strengthened by each member using the power in them to impact the whole Body. But when we restrict women *from* the power and then attempt to reduce the power *within* them, we weaken the entire church.

There is a medical term, *synapse,* which refers to the minute space between a nerve cell to the other nerve cell, through which nerve pulses are transmitted from one to the other. [40] Many think of this as being the link that keeps all cells operating properly. It is thought to be the entity that fires one cell to the other. There is also a condition that can occur in the body where the myelin sheath, the coating or insulation around the message-carrying nerve fibers in the brain and spinal cord can be attacked. Where myelin has been destroyed, it is replaced by plaques of hardened tissue (sclerosis). This occurs in multiple places within the nervous system creating the disease MS or Multiple Sclerosis. [41]

A sclerosis has occurred in the Body of Christ. The spiritual insulation and covering over our sisters has been worn away through power struggles and replaced by hardened attitudes that have separated us from one another. The Body that should be so *fitly joined together and compacted by that which every joint supplieth* has witnessed an erosion of the message-carrying nerve fibers designed to hold us together. Therefore, the message that comes from the Head of our Body is not properly transferred to all the parts and the joints simply

34

do not supply the power needed for the Body to perform at its highest level. The power, *dunamis,* that we need to fire from cell to cell has been disengaged, leaving us limp, immobile and unable to stand on our own. We have a message and a mandate that calls for us to explode within the earth, covering it with the Word but we stand ready instead to implode, turning on each other in an autoimmune reaction.

If we are to ever *come in the unity of the faith, and of the knowledge of the Son of God, unto a perfect man, unto the measure of the stature of the fulness of Christ,*[42] we must detonate the power in our women. If we are to walk in maturity as a whole Body, we must ignite our female cells that their power might be adapted to the need of the church.

Lest we stink; lest we sag...let us explode.

Larva

The scientific term for the young of any stage that undergo a complete metamorphosis in the course of development into adults is called Larva. This is also the stage of the butterfly that we commonly call the caterpillar. After chewing its way out of the egg, a newly hatched caterpillar usually consumes its eggshell, then begins feeding voraciously on the leaves or other parts of its host plant.[43] It is the principal feeding stage in the life cycle of a butterfly and it is during the caterpillar stage that an insect does all its growing. Many are rather like non-stop eating machines with few breaks for resting. In order to get bigger the caterpillars have to shed their skins. This is done during a process called ecdysis (molting). Before ecdysis can start, the caterpillar has to seek a suitable place away from danger. The old skin is peeled back from the top of the head where the split occurs. The caterpillar is vulnerable at this stage as the new skin is very soft and provides no support for movement. By swelling up from the inside the caterpillar is able to expand its new skin until it sets hard.[44]

Whilst feeding, caterpillars have to cope with attacks from predators and parasites. They have evolved an interesting variety of ways of deterring or avoiding predators. One method

36

is to try to keep out of sight. This is done either by having background matching colors or living perpetually on the underside of leaves. But the underside of leaves are not always a safe place.[45]

Chapter Seven
Our Daily Bread

The strength of any organism or organization can be determined by evaluating that which sustains it. Sustenance is typically provided through a food source, that which is given to satisfy an appetite and to meet physiological needs for growth and development. An improper diet yields an unhealthy body resulting in a dietary condition caused by a deficiency or excess of one or more essential nutrients: malnutrition.[46] It is for this reason that we typically exercise care and concern about our food, which serves as the fuel we need to maintain our body temperature and to keep us going. Over time, we become mindful of that which we indulge so that we might remain free of sickness and disease that can result from imprudent eating. Most caring parents or adults will restrict a child to a limited intake of sugar and sweets, despite the child's desire to have it, because they realize that to not do so exposes the child to negative consequences that impacts them physically for years and perhaps even the rest of their lives.

The Body of Christ is as strong as its sustenance, its teaching. It is that which holds it together and which determines its growth and development. Therefore, there are fewer things more important to the Body than the consistent impartation of the Word of God from His servants to His people, and the rehearsing of His Words to the minds and spirit of the saints through personal study.

When Satan tempted Jesus in the desert and encouraged Him to turn the stones into bread, His response as given through *The Message,* a modern translation of the New Testament, was, *It takes more than bread to stay alive. It takes a steady stream of words from God's mouth.*[47] That was true then and so it is today.

Years ago, it was customary that mothers of old would feed their young children food that perhaps their teeth had not developed enough to chew. So they would chew the food first, take it from their mouths and place it in the mouths of their children. In doing so, they were able to protect the child from strangulation on pieces that were too large for their small systems to digest or from the heat of the food that was perhaps too hot for them to handle. But they also took away some of the

potency of the nutrients in the food by chewing it first. They were providing the child with a taste of grown folks' food before their teeth and bodies were actually ready to digest and enjoy it on their own.

We are sustained as individuals and as a Body, by the steady, consistent hearing, reading and studying of the Word of God. However, the challenge comes in our need to make sure that the bread of life broken unto us, which comes from the mouth of God through His servants, is not altered in such a way that those things which bring the *entire* Body health and wholeness are not taken away or withheld from us in the translation and in the teaching. We do not need men to determine what our souls and spirits can digest and make spiritual decisions that will decide our Biblical dietary intake. We can see how this happened in Judaism, when the traditions and learnings of man, the halacha and the Talmud, were taught in conjunction with the Torah, the actual law. All mixed together, truth became indecipherable, resulting in bread being fed to the Body that was deficient in the nutrients that would be sufficient in making and keeping it strong. As a result of that happening, we are still struggling with the side effects of improperly prepared bread and wrestling with the recipe that

was not nutritionally strong then and that threatens to weaken us today.

The Bakers of the Bread

Women have for too long, in comfort and convenience, allowed someone else to prepare their bread. We have chosen to be fed from some other mouth when we could have and should have been diligent in our own study and sought truth for ourselves. Instead, as Robert H. Rowland states, ordinary Christians (and women in particular: authors' note) tend to let the scholars of their choice do their study and thinking for them. The individual search for truth gets swallowed up in loyalty to our preferred scholar, preacher, teacher or party. Since scholars, preachers and teachers usually enjoy the praises of their followers, it is easy for them to encourage the party or denominational spirit where their positions on issues will be accepted and followed.[4]* The fair and impartial truth is then compromised by those who seek to serve their own purpose and not that of their flock or the Body of Christ as a whole. Rowland further states, Once in positions of power in the church, dominant personalities tend to exert much of their influence and energy in maintaining the status quo and making

sure no one rocks the boat. The average Christian, in fact most Christians, accept the Biblical positions of these dominant personalities because they have neither the interest, scholarship ability, spirit of inquiry nor the courage to challenge dominant leaders. Most will not even question those in positions of power, even when doubts surface[49]

The Makers of Our Milk

In the earliest developmental stages of a child there is nothing more important to it nutritionally than to receive wholesome milk. Milk from females provide all the nutrients that a baby needs, as well as substances that promote growth and help fight infections. Hormonal changes in the female body during pregnancy prepare the breast to produce milk. After birth, when the baby first sucks on the mother's breast, the nerves in the areola (the colored, central part around the nipple of the breast) stimulate the pituitary gland, located at the base of the brain, to release the hormones prolactin and oxytocin. Prolactin makes the lobules, or milk-producing cells, in the breast secrete milk. Oxytocin causes the smooth muscles surrounding the lobules to squeeze the milk in the breast's ductal system, a response known as milk ejection. The ductal

system carries the milk to the nipple where the baby suckles.[50]

For the first three to four days after the baby's birth, the milk released from the mother's breast is colostrum, a thick, yellowish fluid rich in protein, antibodies and other infection-fighting agents that is more concentrated than mature breast milk. Colostrum is replaced by early, or transitional milk, which is thinner, lighter in color, and more plentiful. Within about two weeks of the baby's birth, early milk is replaced by bluish- white mature milk.[51] It is so interesting to note that the woman's body automatically responds to the need of the baby's craving for food and provides it the exact nutrition needed at the stage and time that is warranted. For this reason, physicians advise mothers to breast feed the baby on demand rather than by an hourly schedule. This practice not only ensures that the baby receives the proper nutrition, but also that the mother's milk supply is maintained. It is also important that a feeding session not be altered until the baby is satisfied because the milk at the beginning of a feeding session is different in composition than milk at the end - the hindmilk is much richer in fats. Therefore doctors recommend that a breast-feeding session begin and continue on one breast until the baby spontaneously stops feeding. Halting feedings after a

predetermined time may prevent the infant from obtaining the extra fat calories in the hindmilk necessary for proper growth.[52]

As newborn babes in Christ we are encouraged to *crave (thirst for, earnestly desire) the pure (unadulterated) spiritual milk, that by it you may be nurtured and grow unto [completed] salvation.*[53] And with the faith of a newborn baby that snuggles to the breast to be fed, women, we have opened our mouths to receive from those who have tainted our milk and infected our minds with a word that is less than wholesome for our spirits. Or our feeding sessions have been cut short, abruptly ending our thirst for truth at another's breast, giving us only that which was sufficient in the feeder's eyes and withholding the hindmilk that was designed to keep us healthy and to set us emotionally free. But we continued to suck until one day we recognized that there was a blockage in the ductal system and that something had occurred to alter the spiritual milk-producing cells and the prolactin was generating something other than holy milk.

A Taste That Opened Our Eyes

Still in the process of our feeding we got a taste of truth along with the tainted and it was just enough to open our eyes.

44

In the manner of the young child who receives a taste of adult food from the mouth of its mother and refuses thereafter to drink their formula or eat their processed foods, we have *tasted the good word of God* [54] and our palates are no longer satiated by that which is not nutritionally sound. We heard the Psalmist say *Oh taste and see that the Lord is good* [55] and we sampled enough of truth that the flavor has lingered on our tongues allowing us never again to be satisfied by spoiled milk or molded bread. As we crave for the spiritual milk, we recognize that the Body is not automatically responding to our desires or needs and often we are not being fed. But we will not accept a famine because we have seen the feast that has been prepared at a table where there are seats reserved for us. Because we still sit at a table of some other's choosing, we are asking that you purify the milk and altar your recipe to properly bake our bread. But should you in pride and prejudice determine for us a diet that will keep us in a state of malnutrition, we are calling upon women to so prepare themselves that we will produce from our mouths a word that will bring sustenance to the Body of Christ in a way that it saves and enriches all of our lives.

Chapter Eight
What's Eating Us

As the physician slowly completed his examination, he took off his glasses, sighed and looked at the patient. With concern she wondered what the prognosis would be and hoped that it would finally bring an end to the speculation of what had been bothering her for months. Shaking his head he said, *I have done every imaginable test to get at the bottom of this ailment. I have thoroughly examined you and found nothing. We have even studied your food intake. I have concluded that it is not so much what you are eating that is at the root of this problem, but it is something that is eating you.*

Women have traditionally suffered from many stress-induced illnesses that have resulted from the treatment that we have received at the hand of a male-dominated society. We have been charged with having to play a game he created, by rules he designed and in a time frame that never allowed us a fair chance. And after succeeding against all odds, we have had to deal with name calling and criticisms that have questioned our sexual preferences, doubted our genuine love for our family and compared us to animals. It has been expected that we be sensual and soft spoken, yet handle ourselves *like a man* if we

are to assume leadership roles and responsibilities. We should of course be fine and feminine at all times, but forceful; prissy and polished, yet professional; sweet and sensitive, but strong. We must be as smart as men but to preserve a peaceful working and worship environment, refrain from showing it. Sister Angela Ann Zukowski, a University of Dayton professor and the first woman appointed to serve on the Vatican's Council for Social Communications, said that in any religious tradition, as well as in any male-oriented business, women have to be twice as good, work twice as hard, and be twice as effective in order to demonstrate what they can do.[56]

In the business world, women often complain about *the glass ceiling,* that invisible barrier that impedes their progress up the corporate ladder. In the religious world, women call it *the stained glass ceiling,* a barrier that many contend is thicker, more opaque and less permeable. The stained glass ceiling has kept them from the top jobs in the church and often from the pulpit itself.[57] Whatever the name or the place in which it is positioned, there is clearly a limit that has been set by man for women and much of her time and energy is spent either bouncing off that ceiling or trying with all her might to crack it, so that she and other women might see the light that radiates

above and beyond it. After 213 years, the African Methodist Episcopal Church elected its first female bishop. And on July 12, 2000, Rev. Dr. Vashti McKenzie of Baltimore, MD, declared that *the stained glass has been pierced and broken.*[58]

There were women who sat in Cincinnati in July 2000, and cried during the vote to end the two-century-long ban on women in the bishopric of the AME Church. There are women who cry and still hope that such a ban will also fall in other major denominations. But until then, our cries are muffled through masked faces that pretend that all is well, when the discrimination and injustice is literally making us sick.

The Effects of a Sick Heart

The wisdom uttered in Proverbs says, *Hope deferred makes the heart sick, but a longing fulfilled is a tree of life.*[59] It sickens us to see so many women, who are far more capable than her brothers, left behind and set aside to watch business as usual reinforce the status quo of our church leadership. When our hopes for change are dashed and our dreams continually deferred, we are repulsed by the indifference demonstrated by men that we have faithfully supported for decades. We become nauseated at the lame language used by leaders who would

48

make us believe that they support our efforts for fairness and equity, but who hide and cower in their robes and behind their counsel of leaders instead of being visible and vocal during our time of need. And for the most part we have hidden these broken emotions and concealed our pain to the extent that the silent frustration has served as a rapacious raven and begun to eat us alive.

There are women in the Body of Christ who suffer from stress-induced and emotionally-connected diseases that have always been assumed to be solely caused by something and or someone outside of the Church. But I serve to expose a truth through this writing that the Church has got to take its share of the blame for these disorders. Our low self-esteem, introversion and perfectionism have been fed by your discounting our contributions and limiting us to what you consider as *women's work*. We have become anorexic, bulimic, obsessive-compulsive and depressed. We have ulcers, hypoglycemia and high blood pressure that we cannot control because you are controlling us.

In 1997, a study was conducted by the National Center for Health Statistics that showed by individual self report that Black women experienced depression, restlessness, boredom,

loneliness, upset and anxiety at rates three times higher than white males.[60] Recently, the Surgeon General, Dr. David Satcher said, *I think depression tends to be the dominant factor when it comes to the mental health issues that women of color face.* Dr. Satcher's report, *Mental Health: Culture, Race, and Ethnicity,* says *much of the depression and stress associated with women of color is a result of racism, gender bias, poverty, violence, large family size and social disadvantages.*[61] But because we have been led to believe that depression is merely a sign of weakness, we have covered this very serious illness and made both ourselves and men believe that all was well.

The Clicking of Our Doors

The Rev. Dr. Michael Carr serves as the Chief Chaplain at the Detroit Veteran's Hospital. He specializes in Post Traumatic Stress Disorder and in addition to having written a book about it, teaches counselors and chaplains about the characteristics and symptoms associated with PTSD. The essential feature of this disorder is the development of characteristic symptoms following a psychologically distressing event that is outside the range of usual human experience. The characteristic symptoms usually involve re-experiencing the

50

traumatic event, avoidance of stimuli associated with the event, or numbing of general responsiveness, and increased arousal.[62] In a Clinical Pastoral Education course, he shared a story about a Vietnam Veteran who was a classic PTSD case. The veteran had come to see Chaplain Carr for counsel. After the Chaplain greeted him at the door and invited him in, he closed the door behind them for privacy. To his surprise, when he turned around Dr. Carr discovered the man couched behind his file cabinet and shaking in fear. After a few moments, the veteran simply got up off the floor and took his seat as if nothing had occurred. On two subsequent visits the very same thing reoccurred leaving Dr. Carr baffled at what had triggered it. On the fourth visit, Dr. Carr again greeted the gentleman at the door but did not close it. To his astonishment, the veteran simply walked to his chair and took a seat. They discovered that it was the clicking of the door that had triggered this response. In a single click, all of the agony of warfare was returned to the veteran bringing an emotional and physical reaction.

Decades of emotional abuse at the hands of our Christian brothers has taken a psychological toll and with a single click of our door, there is a resurgence of the pain that we have taken

51

and tolerated far longer than should have been necessary. Because we have quietly suffered through the delegated tasks of vacuuming the auditoriums and frying chicken when we were anointed to visit the sick and head prison ministries, we have suppressed an anger that has eaten at us and made us physically and emotionally ill.

We are sick of being asked to hold revivals and preach at conferences where we are given a fraction of the finances that you give to your brothers and comrades who speak before lesser audiences. You click our door at every occurrence that you go in the back room to count our money from generous donations and make the unethical decision to withhold from us the entire amount. You make us ill when you approach us for sexual favors and then question our sexuality instead of our holiness when we turn you down. You discount our response to you as merely *emotional* and we unapologetically agree. But know that it is an emotion that is stirred by our years of battle for buttresses where we have been victimized by an enemy with whom we often slept and loved. We have come to your alters for prayer and seeking healing. We have been slain and got up off the floor still sick. We have submitted ourselves to every test imaginable and have searched ourselves for answers. And

even though we know our spiritual diet is oft times insufficient, we have come to the unavoidable conclusion that much of what we suffer is not only a result of what we are eating, but because of what is eating at us.

Chapter Nine
Who Are We?

The story is told of an American soldier during World War II that had been lost and separated from his troops in France. Tattered and distraught from the ravages of war, he stumbles into a crowded theater and makes his way onto the stage. As the audience stares and silence replaces the chatter, the soldier, who is frail and disoriented asks, *can somebody here tell me who 1 am?*

The search for identity can be found at the root of much of the societal ills that plague us today. This search can be felt by hundreds of thousands of teenagers who join gangs each year seeking support and approval that is lacking at home. It can be seen in the desperate addict who has replaced all sense of self with a drug of choice, or the alcoholic who cannot stand and deliver her presentation without the crutch that a morning drink brings. Too much can never be said about the importance of our knowing who we are.

However, there is a danger when we seek our identity at the hands of someone else. We cannot afford to allow someone who has no vested interest in our well being to determine how we will see ourselves and the image that we will have. It is a

power and authority over us that is undeserving for the casual relationships that we share. To ask someone who we are is to allow them to define us and our purpose. We then become limited by their thinking and their choices for us and we lose our ability to dream and seek the impossible for our lives.

African Americans were estranged from their identity through slavery. We were taken from the motherland of Africa where we knew civilization and respect for the bond of family. We lost the comfort and security of self when we were separated from one another and placed into a surrounding that was not familiar and with those with whom we could not communicate. The image of what was acceptable changed before us and we spent hundreds of years and billions of dollars trying to fit that image and to make that image fit us. Eventually various voices began to speak about the error of what was reflected in our mirror and we began to search for that paradigm which better identified the African American experience. But in the search for this identity, we often turned on one another, questioned the authenticity of our history and severed relationship with the land that we have left behind. For us it has proven to be a costly search.

The Day We Learned to Type

A child sat watching Tarzan and remarked to his father that every week Tarzan would swing through the air on his rope, drop down into the muddied waters and slay the waiting alligator. *Dad*, he asked, *when will the alligator ever beat and eat Tarzan?* Without looking up from his paper the father sarcastically responded, *when the alligator learns how to type.* The father was signifying that the fate of the alligator was tied to the one who controlled the outcome of the script.

The identity of women has always been written at the hand of man. With the ink from his pen we have been made to be whores and sluts, and deemed the reason behind the fall of man and represented as the weakness of civilization. We are taunted in music and decried in poetry. Our rape and slaughter is commonplace in videos and movies. We have been left out of church history because of the theological and cultural conditioning of the writers who tended to assume that women had no important leadership roles in the church.[63] But one day we learned how to type. Now it is incumbent upon us to rectify the brokenness of our image and to set straight the truth of who we are.

Our identity was established by God the Creator in the beginning of time. As Elohim, He made us in His image, in His likeness, giving us His identity. *So God created man in his own image, in the image of God created he him; male and female created he them.*[64] Our search for significance need only return to the scriptures that clearly indicate that we are designed by God for His purpose. He gave us dominion along with man that together we might rule the earth. He did not give us dominion over one another but over all of the things that He created in the earth.[63] He did not expect for us to take our eyes off of Him to see if we could be reflected in others. In Him we live, move and have our being.[66] Paul tells us in his letter to the Colossians that we are complete in Him.[67] Therefore, to attempt to find completeness through any other source, including success, the approval of others, prestige, or appearance, is to be taken captive through philosophy and empty deception.[68] We are who God says we are!

We are More...

We cannot sit idly by and allow ourselves to be discounted and our work diminished by those who don't know who we are. We have not yet reached a level of perfection, but we hold fast to Him who has made us whole. We are the clay on the potter's wheel and He has made us...more. We are more than cooks, we are compassionate counselors, capable of bringing about healing to wounded souls. We can do more than read your announcements from your bulletins, we can preach the Word from your Bibles. We can teach Sunday School and your seminaries. We can pray, pastor and prophesy. We can do more because in Christ we *are* more. More than forsaken, we are forgiven. We are not judged but justified. Pulled from our shame we are sanctified. More than appointed we are anointed. Instead of being condemned we are both called and chosen. We are more than conquerors through Christ who has loved us.[69] We no longer seek your approval but we want you to acknowledge us through your respect. We are not defined by any other than our Creator who has given us the power to become all that He has placed in us. It is He, and He, alone, who has determined who we are.

Chapter Ten
Hidden In The House

Very few things are more frustrating to an individual than to know they have something in their home and they cannot find it. To have something important to you that is available but not accessible is irritating at best. So you search for it because you recognize that its value is worth the pursuit. Sometimes, however, things can be hidden or even misplaced, and its value not be known to you. Often times these things remain lost or concealed because one does not consider them valuable enough to be worth the effort of the search. But the misconception as to its value does not diminish the true worth of that which is hidden.

Within the house of God there are hidden gifts, talents and anointings that lay wasted because leadership fails to recognize its worth. Sometimes this is because they fail to see their own need. But all too often, it is because the package that contains the answer to what is needed is different from what is wanted by them.

One of the marvels of the full-grown butterfly is that in its second stage, it is completely concealed as something different

than what it is to become. Few people look at caterpillars with the same awe and interest as they do butterflies. Even the curious child who would see them crawling and pick them up to place them in jars do not see the beauty of what lay hidden within them.

The Patience for Evolution

In many instances we simply do not exercise the patience to watch something develop and evolve. We have become such a microwave society in that we desire to see things materialize instantaneously or we cast them aside. No longer do we hire people and put them in extensive training programs so that we can develop them as suitable to our needs. We do not consider it to be cost effective. So we rush them through our learning modules, put them to work and pressure them to conform to what is expected of them despite our not having adequately prepared them for the job. We do know, however, that this scenario is often different based on who is being trained. Minorities and women have not had the privilege to develop and evolve, as have Caucasian men. This has often demonstrated that the patience with one's development is frequently tied to the level of expectation of what they will

bring to the organization. Not much is often expected of women; therefore not much is invested in our evolution. Within our own culture many have inferred from the paucity of women in the highest levels of corporate management that *women are not leaders and therefore shouldn't 't be.*[70] This inference is made without regard to the system that has kept us from becoming that which we should.

No place is this more obvious than the Body of Christ. There are some denominations that begin developing their sons as early as seven and eight years old, giving them positions above women who are their mothers and grandmothers. For those churches that do not allow women a vocal and public role in the worship service, you will often see very young boys being trained for leadership positions while mature, educated and capable women sit at their feet. From the pulpit they will stumble over words that they cannot understand while reading scriptures to women who have to whisper the right words to them from the pew. Many men who dare argue that they do not place women in more leadership positions because the women are not prepared for them. But if we, as women, are not prepared it is because men have prohibited our preparation when they will not allow our evolution.

61

Fear... The Key to Our Closets

Roland Croucher says that *the main reason why there aren't more women in positions of leadership is psychological. The little boy in us men can't cope with strong women: we left home to get away from maternal authority. Indeed, many men seem to have a near-pathological fear of losing power to a woman. Few men have women mentors. They usually don't read books by women.*[71]

There is one area of church leadership that was typically given over to women and that was Sunday School. It served as an important outlet for women's creative energies and at first grew out of a concern for impoverished children. Because these children worked long hours during the week, they could not take advantage of public education, and so had little opportunity to learn even the basic skills of reading and writing.[72] At first, church leaders were cool to the idea of teaching literacy skills on Sunday. But Martin Marty notes the underlying reason: *Ministers at first opposed the early Sunday School movement not simply because it was new or was a threat to established ways of doing things but because it was often in the hands of women*[77] Fearing that *these women will be in the pulpit next,* some pastors and church leaders denied the

use of their facilities for Sunday School work.[74] This deep-rooted fear has continued to keep talented women hidden in the Church and locked out of its pulpits.

Resurrection Time is Nigh

Women have dealt with this injustice in various ways. When the fear in men has been realized, we have often camouflaged our own skills to make them (men) comfortable. We have *dumbed ourselves down,* so as not to appear intimidating and most have simply led a silent, but frustrated existence, hoping that one day there would be real change. We have convinced ourselves as well that it is to our best interest to lay hidden, not desiring to stir the pot or to appear that an insurrection was being mounted. But I openly call for a resurrection today. I implore women to come from beneath the pews and out of the closets so that the power in them might be revealed. We have been buried long enough and even though by now we stink from the decay of our dead spirits and the death of our dreams, it is still time for us to get up and come out. We must come out of the tombs that have held us captive to the machinations of fearful men. We must come out of the graves that have buried our hopes and made us to think less of

ourselves than we should. We must arise from the caves that have concealed the light of truth and kept us groping in the darkness of misguided teachings. Ignorance is too weak to hold us; fear cannot contain us; the love of God enfolds us. It's time that we arise!

Chapter Eleven
Beneath Our Skin

God has made the human body to be an extraordinary configuration. With great detail He has created us to function at a maximum capacity, with every aspect contributing to its overall effectiveness. There is nothing about us or in us that is considered as without purpose. From the minutiae of our eyelashes to our massive brain, we have been designed as an organism that functions interdependently, with each part having its vital role. Indeed, we are fearfully and wonderfully made.[75]

An important part of the body is the protective organ, which covers its entire surface: the skin. It is considered as the largest organ of the body. It forms a protective layer over the body to help prevent injury and disease. [76] Our skin protects the network of tissues, muscles, bones, nerves, blood vessels and everything else inside our bodies. Its purpose is also to regulate the body temperature. Essential to a person's survival, the skin forms a barrier that prevents harmful substances and microorganisms from entering the body. In addition to protecting body tissues against injury, it prevents the loss of life- sustaining fluids that bathe body tissue.[77]

We can only marvel at the creation of man at the hands of God when we consider how our bodies have been designed and how each organ, tissue and sinew function with distinct purpose, though not independently, for the betterment of our entire bodies. It fascinates us all the more when we see how God has compared His greatest creation to His church. *This* Body also has many organs (members) that need to function within their designed purpose so that the entire Body might remain healthy and whole. The apostle Paul, whom many use to preach the divisive message of sexism and inferiority, speaks clearly about the need for every part to recognize the significance of the other. Although the foot is not the hand and the ear is not the eye, each has a distinct purpose and is needed to function in its proper place. *For the body does not consist of one limb or organ but of many.*[78]

The Need For New Skin

There is an elasticity to our skin, allowing it to stretch, enabling our ease of movement. In the manner of the caterpillar, we shed our outer layer of skin, the epidermis, which has four layers of cells that are constantly flaking off and being renewed.[79]

Jesus offered a parable in three of the synoptic gospels about the bottles that held wine in the first century. They were called wineskins because they were made of animal skins sewn in the shape of a flexible bag. At first they were soft and pliable, but with age they became brittle. Since wine gives off gases and expands as it undergoes the process of fermentation, a wineskin would have to stretch to accommodate the expanding wine. Non-elastic, old skins would burst during fermentation. Jesus used this as a metaphor: old wineskins represented the Jewish system, which was unable to accommodate the new wine of the kingdom of God. He warned against putting *new wine in old skins* lest the skins burst and waste the contents.

When Mike Cope and Rubel Shelly first founded the magazine, *Wineskins,* in 1992, they offered a purpose statement that would provide insight to the direction of their editorial process and that would explain the overall spirit of their intent in the publication. They stated that, *In His (Jesus) metaphor, the skins are the culturally-conditioned and time-bounded experiences of the people who form the covenant community of God. When those receptacle-carriers of the heavenly message become fixed and inflexible, they no longer serve God's*

purpose effectively. The redemptive message of God's work in Christ at Calvary is needed by people in every sector of today's global village. But the communication vehicles for that message may - no must — adjust to time, place, and need. The church is the oldest and most important vehicle for communicating Christ to the world. It achieves its end by reading and responding to its environment -just as any living organism does.[81]

The Drying of the Skin

Tradition, established religion and institutionalization within the covenant community of God threatens its ability to be an effective receptacle-carrier for the message of Calvary, because these things have limited who would carry that message. Women's participation in leadership is not limited simply according to changes in biblical exegesis or the reigning interpretation of particular passages of Scripture. Rather, the pattern can also be traced to institutionalization of the church (the development of organizational structures), influences from the surrounding culture and the theology of leadership at work in the church.[82] When leadership involved the charismatic choice by God of leaders through the gifting of the Holy Spirit, women are included. As time passes, leadership is

institutionalized where the secular patriarchal culture filters into the Church, and women are excluded.[83] At the expense of the entire Body, certain organs are paralyzed by choice of leadership in an attempt to withhold the oil of the Holy Ghost from them and we become dried up, emaciated, broken and our precious contents, life- sustaining fluids, spill out from under the skin. The skin that refuses to stretch beyond the lost cultural traditions that have all but been abandoned by society except for within its casing, cracks and breaks, wasting that which lay within.

The skin of organized religion has become dried and crusty because it has taken a posture that defends its creeds and traditions above the Word of God. And when this skin has been punctured through age and its lack of pliability, to fend off the infectious elements that could enter to destroy the organs beneath, leadership has tried to patch and mend the old skin, instead of shedding it, to keep it (traditions, and institutionalization) in place. The message, the Gospel that Jesus brought could not fit into the rigid, legalistic system of religion. He called it *new wine* and it will always remain new because it applies to every change in culture and succeeding generation. It is not His desire or intent that this wine be wasted

because traditions try to keep it bound. Rather, He wants the skin to shift, to move or to shed so that the contents might be preserved.

We Will Break...If We Do Not Stretch

Women, who represent the life-sustaining fluids of the Body of Christ, have had to either spill out from beneath their covering in order to do what God has called them to do, or risk being infected by that which seeps into that covering when it becomes tattered and pierced. It is painful to them to have to leave denominations that they have known and loved from childhood because the traditions of those legalistic bodies are content to break, before they stretch. But at what cost have we made such a choice? We have excluded those women who can preach the Word in season and out of season because it has been determined that this is *not* the season for them to produce. We have cut down branches and scattered our fruit, content to sever ourselves from the vine rather than let the entire tree be sustained.

A Body Temperature Gone Awry

Hypothermia is a condition in which the body temperature falls drastically as a result of exposure to cold. A heatstroke is the result of exposure to extreme heat. Both can be deadly. The temperature of the body is a measure of the balance between heat produced and heat lost. Under normal circumstances, a balance exists which keeps the body temperature at best levels for cells to carry out their chemical process.[84]

Our satisfaction, as the Church, with broken skin means we have accepted a less than wholesome Body and adjusted ourselves to a Body temperature that can produce illness and even bring about our death. We have looked beyond our need for a balance to ensure that the metabolic process by which cells transfer energy, maintain their identity, and reproduce[8^] is preserved. We have lost enough heat to make us weak. We have been exposed to enough cold that we shiver. This has left us nursing a fever, a symptom that there is disorder and disease in our Body. We are limping when we should be leaping, short of energy, because we have neglected that which lay beneath our skin.

Chrysalis

When a caterpillar reaches its final size it stops feeding and from its mouth it spins a silken pad that attaches it to a tree or plant. The caterpillar attaches its hind end to this pad and hangs, head down, from the plant.[86] It begins to shed its skin and reveals the new skin. This skin is soft at first but a hard shell immediately begins to form over it. In some cases the shell has a golden shimmer, and so scientists call it a chrysalis. This word comes from the Greek word chrysos, which means gold.[87] The Chrysalis, or Pupa, represents a stage between the fully-grown caterpillar and the butterfly. Metamorphosis means a change in form and in no other stage is it more obvious than in the chrysalis.[88] This stage is often erroneously called a resting place, but nothing could be further from the truth. Inside the chrysalis, the structure of the caterpillar totally transforms. After only a few hours, the adult feathers begin to form. This is the stage that is exposed to much adversity: intense cold, severe rainstorms, or prolonged droughts destroy millions. Furthermore, there is practically no defense from predators and parasites except for camouflage, and the ability to maintain a lifeless position.[89] Hours before the adult butterfly emerges, its wings and other structures become visible through the skin of

the chrysalis. When the butterfly development is complete, the insect pumps body fluids into its head and thorax. The chrysalis splits at certain points so that the adult butterfly can force its way out with its legs. The butterfly emerges from the chrysalis, head first, with crumpled wings.[90]

Chapter Twelve
Quiet, But Not Asleep

I am an invisible man...
I am a man of substance, of flesh and bone, fiber and liquids —
and I might even be said to possess a mind. I am invisible,
understand, simply because people refuse to see me.
Ralph Ellison, The Invisible Man

Listless...though not laid back. Languid...though not lazy.

Still...though not immovable. Silent....though not asleep. This

describes the state of women in the Church over the past few

decades. It is a curious status in that it expresses an emotional

state and a physical reaction. We have been quiet and passive,

while at the same time working furiously to bring massive

ministry visions to pass. No church or successful ministry

anywhere in the world could exist without us. We make up

every grass root effort and are the foot soldiers in Christendom.

We march, but no one hears the patter of our feet and they often

do not even see us coming. But our presence is felt upon our

arrival and our departure would bring about the devastation of

our own army. Heard? Not likely. Felt? Yes. Needed?

Absolutely.

Quiet... With A Passion

A common expression states that there is often *calm before the storm*. Some have described an eerie quiet that preceded a forceful wind and tumultuous downfall of rain that caught many off guard and ill prepared for what was to follow. The stillness betrayed the brewing of the storm. It is a mistake to consider that silence is always an indication that passivity and inactivity is occurring. It is therefore common that a mother of a small child will go looking for them in the house when they become quiet, thinking that *they must be up to something*. For it is not typical for a small child to be quiet when they are not asleep.

Women have played a strong role in the church and the major political, social and fund-raising programs depend heavily upon them for their promotion and success. In most churches, women are feeding the hungry, visiting the sick, counseling youth and holding the bake sales, fashion shows, raffles and teas. Yet in leadership roles, women are primarily acting as Sunday School teachers and secretaries rather than elders and pastors.[91]

The stilled tongues of women in the church in past decades must not be interpreted as our being unaware of what was

75

happening around us, or dead to what was happening in us. With a passion we have worked to create and sustain building funds, host church anniversaries, and bring in thousands of dollars through Women's Day celebrations, and have never had a say in where that money was spent or directed. With earnest diligence, we have served on pastor's aid committees and sometimes not given a vote to determine who the pastor would be. We are shut out of the church board rooms, just as we are the corporate board rooms, yet it has never diminished the zeal that we have had for the overall work of the Church. The sad result of this is the fact that both men and women have come to expect that this is simply the way it is and should be.

Quiet... With a Purpose

There are numerous examples in which God took someone and even placed them in cover or hiding to prepare them for a distinct purpose and time. He hid Moses as a child and allowed him to be groomed by the very people he would return to and command the freedom of the Israelites. He placed a young maiden named Esther in the King's palace and hid her nationality, but not her beauty, so that she might receive favor and be positioned to make a difference for His people.[93] God

has allowed the stillness of women to exist, not because He desired that we be overlooked and discounted, but because He was preparing us for such a time as this. He has given us purpose and in His divine timing, He will bring to pass that which He called us forth to do.

Quiet... With A Promise

The farmer took his young grandson out into the empty fields and said with a huge smile, *son, this year is going to be a huge crop, so we need to get ready for our harvest.* The young child replied, *well, granddaddy, how can you know how big the crop will be before it comes? Why, son,* the gingerly old man replied, *it's because I can see the promise in what I've planted.*

God chose David as a young boy to replace Saul as King of Israel. It did not matter that he was tending sheep and was not considered as the favorite candidate for the job. When Samuel was told to anoint him, the promise of God rested upon Him and was to be fulfilled, despite his age, his occupation or his looks.[94] Quietly, David returned to his sheep and then worked in the very service of Saul until God was ready for the promise in him to be manifested.

There is a promise upon women in the Church of God. We have been chosen to not only be His people, but to lead them. Our gender and looks were not of our choosing and should not rest to the choice of others who would try to determine the accomplishment of our promise. We must see the promise in each other and ourselves and know that this promise is going to be fulfilled to the glory of God's Church.

The Deception of A Circus Elephant Mentality

The elephant is one of the most powerful mammals that exist. Highly intelligent and strong, it is the largest land animal and among the longest-lived, with life spans of sixty years or more. Throughout history they have been prized for their great size and strength. On the battlefield, soldiers astride elephants have trampled and terrified enemies.[95] It is this same elephant that marches through cities tied tusk to tail with circuses and who respond in docility with children. However, this circus elephant has had to be trained and its mind completely conditioned to bring about such a drastic change. It has been said that as a very young elephant, a chain and ball is placed around its neck and a heavy spike is drilled into the ground. In the beginning the elephant will pull against that chain and it

would cut into its neck. It would pull more but the struggle with the chain was reinforced by the pain in its neck. Finally, this great and powerful elephant becomes so fearful of the ball and chain that it acquiesces to captivity to save its neck. The ball and chain is removed and replaced by a pencil and string, but its response is still the same: quiet, obedient, and passive. It forgets that it is intelligent and strong and a mighty instrument of war, and it becomes a tool for circus entertainment, totally belying what it really is.

Over the years women have adopted a circus elephant mentality. We have become conditioned by the cultural practices of our society and by the misinterpretation of sacred Scripture. There have been times, in which we have tried to buck against the system and resist being placed into the restraints of sexist practices, but the struggle has been painful and we've given up, to save our necks. But the time has come for us to be reminded of who we really are and the fallacy of what it is that holds us, so that we can do what we are called to do. We will not be held in bondage any longer by pencils and strings - giving conditional responses to the traditions and cultural customs that govern our churches. We will be reminded of our promise, live out our purpose and work with a

passion to ensure that though considered invisible, we have a commanding presence. Because we are quiet, do not think we are asleep.

Chapter Thirteen
Poised To Emerge

Just come to tell you, Massa, that I've labored for you for forty years now. And I done earned my keep. You can sell me, lash me, or kill me. I ain't caring which, but you can't make me work no more. The slave owner was shocked, but after a pause, he said, *All right, Jake. I'm retiring you, but for God's sake, don't say anything to the other niggers.*[96]

The voice of one emancipated slave was a threat to the others who remained in chains. The slave owners always knew that the enslavement began in the mind and once thoroughly convinced, chains and supervision were no longer needed because slaves would then police themselves. But it was important to the white authority that the appearance of fear and his ultimate control was evident. Great punishment was generally given to the slave who would try to run away or make any effort towards independent thinking because the *massa* didn't want others to think that it was possible for them as well.

Poised to Speak

The Preacher writes in Ecclesiastes that there is a time and

season for everything under the heaven. There is *a time to keep silence, and a time to speak.*[97] As we live in the end times and await the soon-coming Savior, women, the season for our silence has come to an end. It is time for us to speak! We must speak because our cry is needed to pierce the pupas of other women in waiting so that they might know the right season and time for liberation has come. We must speak, because to continue in silence is to waste the precious opportunity that sits before us. God has ordained this moment and time for us to emerge from hiding and hibernation, to take our rightful and waiting places to lead His people. The solace of our silence has been replaced by the solemnity of the season. It is time for us to speak! The continuance of our transformation and the furtherance of our evolution hinges on that which emanates from our mouths. Our life and our death is in the power of our tongue.[98] It is time for us to speak!

The Pretense of Our Protection

Sometimes we need to be encouraged or even goaded into activity because we are not aware of the gravity of our own situation. This can happen because we are so engulfed in it that we cannot see anything beyond what and where we are. There

are other times in which we can feel as if there is little for us to do and we diminish the impact of our voice. There is a truth that we must also face and that is that we have readily submitted to lesser roles and accepted less responsibility in the Church because doing so made us feel safe. We have even been made to feel that certain things were too difficult for us and too burdensome so men needed to take care of them. In supporting this premise we are upholding chauvinism that is cloaked in chivalry.

A pastor of a newly formed church called a member in for a meeting to explain to her how and why he founded the church and what he wanted in leadership. Because she had indicated no interest in becoming a leader there, she thought the meeting odd and quietly listened to what he had to say. He told her that he would not have women on his Elders Board because he wanted to protect them. He felt that they would have to deal with heavy spiritual issues that might call for unpopular or difficult decisions to be made, so he wanted to keep women from having to deal with those kinds of problems. She listened intently, and when he concluded, got up and went home. A month later he requested to see her a second time. During this meeting, he told her that he wanted her to be on the Corporate Board of the

83

church. She reminded him that if he wanted to protect her he would not expose her to being liable for the actions and decisions of the Elders Board and subject to lawsuits by placing her on the Board that was open to such proceedings. He recoiled and said that he would need to reconsider some things. There was a pretense to his protection that he did not realize himself. The issue was not (and usually is not) protection, but trust. Many men do not trust women with spiritual matters, especially when it comes to those issues that deal with men as well as women.

An Unsafe Place

In the metamorphic stage of the chrysalis, the butterfly is in its most vulnerable state. Secluded within the pupa and hanging from the leaf, there is no means for protecting itself other than through camouflage and listlessness, appearing dead. But though this is a necessary stage, it is an unsafe place. Predators can have their way and dangerous winds and storms can snatch the chrysalis from its leaf, casting it to the ground and to its death. For the very survival of the butterfly, it *must* emerge.

Women have needed to have a time and season for self-reflection and healing. We have needed to be validated and

confirmed by men and made to feel okay about being who we are. And though we found comfort and temporary shelter here, we cannot stay in this place. It is not in our best interest to be in a place that we cannot control and are subject to only those elements that affect and control us. These things have shaped us and have strengthened us for what lies ahead. But we, too, must emerge.

The Need To Come Out

When Esther was in the palace of King Ahasuerus, being groomed to become his queen, she was in a place of relative safety and immune to what was happening outside of her confines. But when her Uncle Mordecai informed her that her people were in danger, he reminded her that through blood, she was connected to those who were threatened on the outside and therefore she was not and could not feel safe." She could no longer remain in the security of secrecy because the threat of danger brought a demand for change.

There are those women, who as preachers, pastors and evangelists have been blessed to cover the country with the Word. Many have opened their conference doors and their pulpits to you graciously, but you are not safe. For the few who

have been consecrated bishop and risen to the rare air of the apostolate, you, too, are not safe. You cannot be safe when your sisters, in disproportionate numbers, are overlooked for positions of Senior Pastor when they have labored in the same vineyard as a faithful assistant for fifteen years. You cannot be safe when you are not paid the same honorariums that men are paid for doing the same thing that they have done. You cannot be safe when you are invited to speak for women's conferences and never included as a voice at conferences for pastors and leaders. Fame and notoriety can be an apparition to reality. They can lull you into a delusion of security. But you are tied to those who stand on the outside begging to come in, and you are not safe.

The Risk To Emerge

Esther not only had to see the need of others on the outside of the palace, but she had to face the risk of her actions should she emerge from her silence and supposed safety. She did so with courage and conviction saying, *If I perish, I perish.*[100] Yes, there is a risk for our emergence into the mainstream of religious leadership and we need to prepare ourselves for it and face it head on. Some men will embrace us and willingly share their power, but most will not. We will be ostracized, criticized and maligned, but we must take the risk to emerge. We may lose speaking engagements that will affect our income, but we must consider the words of W.E.B. DuBois who said that *the cost of liberty is less than the price of repression,* and take the risk to emerge. Our motives will be questioned and our sincerity doubted, but we must take the risk to emerge. Singly we can be slowed down, but together we cannot be stopped. This is bigger than a few of us and important to all of us, so we must take the risk to emerge. Our pupa holds us imprisoned to the peril of our hanging suspended between choices. If we decide to remain confined when we have developed beyond our need for security, we will perish from asphyxiation. If we

choose to step out and step forth we risk being stepped on. But clearly we will perish if we stay in this position. We must take the risk to emerge.

Chapter Fourteen
Strength In The Struggle

Perhaps it is the pictures, both mental and real of the horrors of the atrocities committed against them. Or maybe...it's the shoes left behind; shoes that represented different sizes and different styles of men, women and children as they were snatched from their loved ones and their familiar surroundings and taken to the concentration camps of Auschwitz and the gas chambers that awaited them at Majdanek. These are the images of the Holocaust Memorial Center in West Bloomfield, Michigan. They are pictures that will haunt you long after you have exited the building; images that will not leave you when you have left them.

The slave ship of the Museum of African American History in Detroit is just as daunting. You sense the deep darkness of the bottom of the ship and can almost smell the stench of the filth and excrement that surrounded the bodies. You see the dark eyes peering out of the portholes in fear of the unknown destination that would provide punishment and no protection. Stories, in vivid pictures, that tells of a people that were doomed by the design of man but destined to greatness by the design of God.

In both the history of the Jews and African Americans there is a struggle that has shaped them and made them to be the survivors that they are today. Lining the walls of the Holocaust Memorial Center there are words that speak to the pain of both groups: discrimination, humiliation, propaganda, indoctrination, segregation and genocide. A trip to both of these honored and hallowed venues leave you with a deep appreciation for the past of these people and a respect for the road traveled to bring them to their present. But it is difficult for a woman (Black, White, Jew or Gentile) to go into these places and not feel that there should be a place for her. Surely there is a hall somewhere that holds the pictures of the fallen and the betrayed women, who, too, have endured discrimination, segregation and humiliation at the hands of those in power. There needs to be such a place in Christendom that paints the horrible, but vivid pictures of the pain and struggle of women who stood quietly as they were led (often by their shepherds) to the chambers of isolation and ignorance and left to fend for themselves against a system that they neither created nor understood. Oh, there must be such a place.

One of the things that strike you immediately when you consider these groups of people is the fact that the repression of Jews, African Americans and women was not enough to destroy them. The obvious oppression and subjugation that they endured, that submerged them with unfair laws that restricted their movement and hindered their advancement, knocked them down but it could not keep them from getting up.

In church history, we see practices that allowed women to serve together with men in the early years until the institutionalization of the church transformed leadership into the sole prerogative of men.[101] According to Catherine Clark Kroeger's research, women acted in various leadership roles, including bishop (or elder) and deacon. In the second and third centuries the church ordained women deaconesses along with male deacons. However, as the church institutionalized and absorbed the surrounding culture, it adopted a negative view of women generally and in leadership in particular, something that it did not have prior to this time.[103] Yet women found ways to exercise their leadership gifts, especially in monasteries. In fact, ascetic communities of female virgins predated the male monastic movement. Women flocked to monasteries for

various reasons, including the privilege of studying, writing and traveling. Here, they were able to pursue holiness without the expectations of marriage and family. In addition, women in female monasteries freely governed themselves with minimal male influence. Consequently, women within these communities functioned as leaders and teachers from the beginning.[104]

We're Coming Out

What you don't understand is that as long as you stand with your feet on my neck, you got to stand in a ditch too. But if you move, I'm coming out. I want to get us both out of the ditch.

Fannie Lou Hammer [105] The struggle of women to reach a status of equality has been met with resistance and maintained by a willingness on the part of men to hold themselves and their entire church or organization in a non-productive mode just to keep an important element of it from rising to the top. This causes us both to exert (and waste) energies that could best be used elsewhere in working together side by side. It makes us waste time fighting against ourselves when we should be fighting the real enemy that wars against both of us. But the struggle continues because the atmosphere in the ditch is

suppressive; the air is toxic and for our very survival, we have to fight our way out.

Elizabeth Blackwell became interested in medicine at a time when there were no women doctors in the United States. Twenty-nine medical schools rejected her before she was accepted by Geneva Medical School in 1847. The male students ostracized her and teachers refused permission for her to attend medical demonstrations. However, despite these efforts, she graduated first in her class in 1849 and became the first woman to qualify as a doctor in the United States.[106] She would not stay in the ditch.

The restricted pace and place for women entering higher education in general paralleled their pursuit of theological studies. Oberlin College, from its founding, was open to women. But Antoinette Brown (Hartwell), who was the first woman to gain access to theological training, was actively discouraged from entering the seminary. An Oberlin professor wrote in the school journal that women were *emotional, illogical, physically delicate, weak-voiced, vain, dependent and ordained by God to be mothers and homemakers*, therefore making his case that Brown and others should be prohibited from attending the seminary. She persisted and was finally

admitted, albeit to a hostile environment where she was prevented from speaking in the classroom or pulpit. When she graduated in 1850, she was not allowed to sit in front of an audience, receive a degree or be recommended for ordination. She observed the ceremony from the audience and did not even have the privilege of having her name listed on the graduation record. Despite this unfortunate experience, Brown was ordained in 1853, served a Congregational church and preached until she was ninety years old.[107] Her persistence and drive were too great for the ditch.

The Rev. Ella Mitchell, a Baptist minister and author of *Those Preaching Women* graduated from seminary in 1943, but was denied ordination by the Baptist denomination until 1978. It took thirty-five years for her to come out of the ditch, during which she struggled against unenlightened women as much as men. Her own mother would not accept her as an ordained minister.[108]

The Struggle Has Made Us Strong

There is a wonderful lesson regarding the birthing and hatching of several animals and insects that develop within a shelter or shell so as to ensure their full maturation. Typically, it is the struggle to emerge from their chrysalis, pupa or shell that actually strengthens them to function properly outside of it. The young pheasant uses its egg tooth (a small projection on the end of the beak that falls off shortly after hatching) to crack around the circumference of the shell. The chick then puts its feet into the cracks and pushes shell pieces apart, emerging head first out of the shell that protected it during development and hibernation.[109] The pushing of the shell serves to strengthen the legs of the chick so that it will have the power in them that it needs once it has fully emerged. In a similar way, the butterfly and moth struggles to emerge from its chrysalis and cocoon. Should an observer attempt to assist them in getting out by cutting away at the object that holds them, the wings would be hampered and would remain weak and undeveloped because they are strengthened during their struggle to free themselves into maturation.

Although our fight for equality in Christendom has been tiresome and has taken its toll upon us, we have been made

strong in the struggle. Through our perseverance we have not lost our press and through our diligence we have not lost our drive. We have come out of the fires of cynicism and scorn but our garments are without the stench of suppression. The fight has enlightened us more than it has discouraged us, for it has given us a plan and focus for what we need to do and where we need to go. We do not curse the struggle in our past for it has prepared us for that which lies ahead. In the song, *Lift Every Voice and Sing,* the great African American author and poet, James Weldon Johnson penned so eloquently the words that speak to the pain and struggle of his people.

Stony the road we trod
Bitter the chastening rod
Felt in the days
When hope unborn had died

Yet with a steady beat,
Have not our weary feet
Come to the place
For which our fathers sighed?

We have come over the way
That with tears hath been watered.
We have come treading our paths
Through the blood of the slaughtered,

Out of the gloomy past,
Till now we stand at last
Where the bright gleam
Of our bright star is cast.

These words, along with those that line the walls of the Holocaust Memorial Center and the stories of the Museum of African American History are also words that speak to the pain and disenfranchisement of the woman in American history and in the Lord's Church. Our shoes have also been left behind and they show signs of valley drudgery and mountain-climbing grind. They are shoes of those who have gone before us, who marched but did not get the victory. Together we have persevered through the anguish of the ages and the tribulations of our times. We are survivors of the struggle, and it has made us strong.

Chapter Fifteen
This Thing Is In The Way

The Walking Club of the Beech Woods Recreational Center had convened for their morning walk when they were met with a barrier that would not allow them to enjoy their typical movement and exercise format. The gymnasium had been set up for a volleyball tournament and there was a huge curtain that hung from the tall ceiling to the floor. Because of its position, it obstructed the walking trail around the gym and caused each person to adjust to it as they approached it. It was interesting to watch each individual and teams of walkers as they approached the curtain and then made their changes to get around it. Three elderly men simply formed a straight line each time they approached the curtain because they realized that there was a gap between the curtain and the wall that provided just enough room for one person to walk through. So they walked through it in a single file each time they came near. They made no effort to move the huge curtain but simply adjusted to it. However, there were two women who immediately began to tug and pull at the heavy curtain in an attempt to open it fully so that the two of them could walk by

and through it side by side. One woman was heard to say as she tugged and pulled at the enormous curtain, *this thing is in the way.* They, too, could have walked in a single file and left the curtain in place. Instead, each time they circled the gym and came to the curtain, they pulled it just a little more until they had fully removed the curtain from the walking trail, thus allowing everyone the privilege of walking around the track without the obstruction that had bothered them.

Why The Curtain Must Be Moved

This provided such a plain example of the difference in the thoughts and actions of many men and women. What was comfortable for the men presented a problem, an unacceptable hindrance, to the women. The men were willing to make an adjustment to the curtain and the women were requiring that the curtain be adjusted for them. But lest you think that it was a mere prima donna reaction, the women were doing something that may have seemed selfish but proved to be helpful for everyone in the gym. It was not enough for them to be able to go through by themselves, one by one. They pulled, tugged and struggled with the curtain so that it would be moved to allow more than a single person through. It was important enough to

them for everyone to enjoy an obstacle-free environment.

Such is often the case when women are given the opportunity for leadership. We typically do not find it suitable that only one of us is able to get through a door that will be closed to others like us. Our desire is to push it open so that others behind us can make their way through. When Vashti McKenzie became the first female bishop of the AME Church, she immediately said that there was room for more and avowed that she would be working to ensure that the crack in the stained glass ceiling would never again be closed. *If we say it's going to be just one (female bishop),* Bishop McKenzie said, *and that's it, that's tokenism. My look will be beyond just one. What's the matter with some?*[110]

On October 10, 2001, democrats in the House of Representatives made history by electing Nancy Pelosi as their No. 2 leader, making her the party's whip and the highest ranking woman ever to serve in the House. *Once the succession is broken around here,* Rep. Pelosi said, *there is opportunity for everyone.*[111] Then from 2007 to 2011, she was the 52nd Speaker of the House of Representatives and the only woman to do so, third in line to the Presidency. The advancement of one woman is usually about the advancement of some. More

than often, it represents the advancement of all.

Obstacles In Our Way

One of the more obvious barriers to women enjoying the equality that they have been granted in Christ is the systemic sexism and institutionalization of the Church. Few have been willing to deal with this subject head on or to fully acknowledge that it exists. Among the few is Dr. W. Franklyn Richardson, former secretary of the National Baptist Convention U.S.A., Inc., one of three large Baptist denominations. Richardson says, They (women) have been willing to do the things men haven't wanted to, yet they haven't received the credit they deserve. The church hasn't dealt with sexism because it has been focused on the racial issues that continue to plague its constituents. We are just beginning to understand that sexism is the same demon as racism with a different head.[112]

Victor Hugo once said that *progress is the mode of man; that when it is blocked, just as an obstacle in a river makes the water foam, so an obstacle to progress makes humanity seethe.*[13] Women have endured the degradation of second-class membership in churches for so long that they have begun to seethe. There is a slow burning within them that threatens to boil over into the Church at large and forcing them to consider ways in which real progress can be made and obstacles can be removed.

Patricia Gundry writes, *we have all too easily beaten ourselves bloody knocking at the closed doors of the institutional church asking to be allowed into the established avenues of ministry, thinking all the while that this is the way to do it. Why keep knocking to get in? Why not circumvent the obstacles entirely and re-invent the church along more vital, even more biblical lines?*[114]

Re-inventing the Church and Seeking Respectability

A consistent pattern to the behavior of women is that even as we open new doors for ourselves and others, we seek respectability and validation through the hands of men. In essence, we pull and tug at the barrier in our way, make all the

sacrifices to open a new path only to turn around and observe a stronger one being put in force, often with our assistance. When men had opposed the Sunday School movement, primarily because it was being run and governed by women, they decided to co-opt the movement in forming the American Sunday School Union. The men set the policy and governed the organization, while women, who composed the majority of its teachers, did the grassroots work. As the movement gained respectability and became established, women effectively handed over the reins of leadership to the men. Once again, institutionalization virtually eliminated women from leadership positions within an important area of the church's ministry."[5]

We can see this over and over again in religious movements. We have tied respectability to masculine identity and consequently we have minimized the roles of women, or left them out of leadership positions altogether. Even those churches with women pastors are generally found to have more men in leadership positions when more women still fill their pews. The women pastors have felt a need to open the curtain for men to walk through to give their church respectability and have failed to see that the barrier had been reestablished in closing out other women who sit right at their feet. To re-

invent the church we must re-invent our thinking. We must recognize how deeply woven institutionalization is within the conscience of the Church and that no one, not even those victimized by it, is impervious to its insidious grasp.

To move this thing out of our way, we must awaken our thoughts to the reality of its existence. We must be aware of the damage that it brings to the Body of Christ as a whole and to the daughters of God in particular. Rowland Croucher reminds us that *the church is immeasurably impoverished when more than half its members are debarred from exercising leadership ministries not on the basis of the presence or absence of giftedness or competence, but simply because of gender.*[116] Floyd Rose adds that *when we assign roles and give a place to somebody based solely on the accidents of race, culture, class or gender — things for which people are not responsible, it defies the best that is in us, and we rob ourselves of the best that is in them.*[17] We must insist that the Church ascend to the level of its potential as established by and through the Word of God beyond what creeds, traditions and scholarly thinking might take us. To allow unscriptural, ungodly and unjust barriers to remain in the Body of Christ without challenge is to assist in its slow death by suicide. We must take our collective

hands from around our own throats and put them to the plow to

move this thing out of our way.

Chapter Sixteen
Breaking Down and Breaking Through

Between 1949 and 1961 about 2.7 million people left East Germany via West Berlin to take advantage of greater economic and political freedom. In order to stop the outflow of some of its most educated and well-trained citizens, East Germany constructed a barrier of barbed wire and concrete around West Berlin. Berliners woke on the morning of August 13, 1961 to discover their city had been cut in two.[118] These temporary fortifications were later replaced with a permanent concrete wall. For the next twenty-nine years, the Berlin Wall stood as a concrete curtain, a 2.8 mile long scar between East and West Germany. From the time of its erection until its fall in 1989 few East Germans managed to escape and at least eighty people died trying to cross the border.[119] On November 9, 1989, to the celebration of both East and West Germany, Britain and the United States, the wall came down. But there was still talk of their being a *wall in the heads.*

It's In Our Heads

If folk can learn to be racist, then they can learn to be antiracist. If being a sexist ain't genetic, then people can learn

about gender equality. Johnetta B. Cole, former president of Spelman College.[120]

Before the butterfly can emerge as a mature adult she must force herself out and through her chrysalis, the covering that has concealed her during her development. This thin, and sometimes shimmering shell has to split to allow the butterfly the surfacing that is necessary for her survival. Because the shell is transparent, one can see the wings of the butterfly in this stage and know with confidence that it has developed properly and that its emergence is imminent. As the butterfly is emerging from her chrysalis, it is interesting to note that she does so head first. The head is the center of sensation. It bears the butterfly's eyes, antennae and mouthparts.[121]

Much of the problem with women and leadership in the Church is in the head (or thinking) of individuals. This thinking has been conditioned by culture and has become so ingrained within our consciences that we respond to error in teaching as if it is truth and in the manner of the early Jews, we pass this thinking (halacha) down to generations. Robert H. Rowland says *error can be passed on as easily as truth. It can be defended with equal vigor. But when error is passed on and defended as truth, succeeding generations are imprisoned, and*

the church suffers.[122] Women, and subsequently the entire church Body, are imprisoned to sexist practices and inferior thinking. Because we have accepted the manner in which we have been treated for so long, our lack of regard and disrespect have been looked upon as normal. And normal has been translated as right. Before we can set ourselves free, we must first break down and destroy error, but that will happen only when we first recognize that there is a problem.

A Breakthrough in Our Thinking

A group of African American scholars were invited to tour Cuba in 1994 in a cultural exchange between the universities throughout that country. In addition to the academic and intellectual dialogues that were interchanged, a small ensemble sang music of the African American experience and was well received. Often crowds would line up for hours and pack the buildings where the ensemble was scheduled to sing. There were occasions in which the Cuban choirs would sing as well, offering a similar exchange as was demonstrated in the academic discourses. The Cubans have a genuine love for music and their appreciation for Negro Spirituals was evident in the superb manner in which they performed them. On one

evening, however, they offered a special tribute to their American guests that left them sitting in shock. The interpreter announced that they were dedicating their most popular song to their guests and it was titled, *The Big Lip Dark Skinned Woman.* There was a collective gasp among the Americans and they looked at each other in shock and dismay. The Cubans had been so gracious and accommodating, it was difficult to believe that such an insult would come from them in a crowded public setting. The audience stomped and cheered as the choir sang and dramatized the song that included several men in pursuit of the big lip dark-skinned woman. But the African American scholars found no solace in their joy. As the song concluded, one of the scholars decided that he would address the choir on behalf of his group. *En los Estados Unidos,* he began in Spanish. Then after a pause he continued, *you'd have a fight on your hands right along now.* The other scholars nervously smiled and agreed, but the Cubans seemed offended. Their faces turned from smiles to serious and through their interpreter they said, *in our country the big lip dark-skinned woman is an object of pure beauty. The fact that you don't consider her beautiful is a problem for you in your country but it is not for us in ours.* The scholars were stunned, though not just at those

109

words, but at their own thinking. There they sat, some of the most accomplished people in the free country, whose collective resumes could have extended from one end of Cuba across the Atlantic Ocean into Miami. But their intellect and academic acumen veiled a consciousness seared by the culture and traditions of their land; a culture that convinced them that they were ugly and that beauty was defined and determined by paradigms different than themselves. Therefore, a compliment was translated in their thinking as a curse based on a preconditioned mindset that they had unknowingly received as truth.

Our culture and traditions have blinded us to truth and have redefined what is normal and what is right. It takes a jolt to our very belief system to make us realize where we are in our thinking before we can see how this thinking has made us slaves to culture and foreigners to truth. However, Edwin K. Broadhead believes that this can change. *Willing learners can be taught. Cultures yield from the outside and give way to change. Passing time and persistent people may indeed tear down these barriers. This is our hope.*[123] In *The Message*, Eugene Peterson translates Romans 12:2 as saying: *Don't become so well-adjusted to your culture that you fit into it*

without even thinking. Instead, fix your attention on God. You

'll be changed from the inside out. Readily recognize what he

wants from you, and quickly respond to it. Unlike the culture

around you, always dragging you down to its level of

immaturity, God brings the best out of you, develops well-

formed maturity in you.

It's In Our Mouths

On September 8, 2001, history was made in Tennis and in

America when Venus and Serena Williams became the first

sisters to play in the championship game of the US Open in

New York. That date had also marked 44 years to the day when

Althea Gibson became the first African American female to

win a national championship, the French Open. Although the

Williams sisters are now considered the darlings of the tennis

world, they were not met with open arms in the beginning,

primarily because their father, Richard, who also managed their

careers was seen as having a style and language that was not

befitting the tennis establishment. *They said Richard 'Williams*

was arrogant, that he served from the mouth and that he hurt

his daughters' chances not only by criticizing the racism and

the stuffiness of the people who run tennis, but criticizing the

111

game itself. Education is power, not chasing around some tennis ball, he always told them.[124] Richard Williams also told his daughters that they would be the best in the world and he refused to allow them to hear and believe what society and culture would have pressed in their thinking, that tennis was an all-white sport. Consequently, Venus and Serena always spoke with confidence about their chances of winning major tournaments because their belief system had been dictated by their father's words and not by their culture and traditions.

A Breakthrough In Our Speech

In order to transform our thinking and to completely break down the walls within the Church that separate women from leadership roles and positions of power, we must make a conscious effort to see to it that there is a breakthrough in things that are said about women from our pulpits, in our literature and in the messages of our conferences. Our Women's Day messages must move from being about females who love to shop and who cannot get a man to those things which can empower them and the entire church, moving it toward a more equitable distribution of responsibility and power. Women need to stand tall in pulpits and rightly divide

the Word of God regardless of who sits in the pews in front of them. Messages from women about women that reinforce the shallow thinking and childish behaviors that society has established for us must be condemned and not tolerated. We cannot allow error from the mouth of women to be dismissed and ignored because they are women. Education *is* power, and we must realize that every word to be spoken over and into the lives of girls and women is an opportunity to educate and transform them. It is no longer acceptable to make the typical blanket statements about women that stereotype them as being too emotional, weak and selfish. We have heard those things for so long that they do not even ruffle our feathers. It is normal to hear and therefore we think it is right. But we will no longer allow this error to be received as truth and defended as truth, because the real truth has set us free. Whereas our goal is not to fight each other, our aim is to defend and protect truth.

The very time I thought I was lost, my dungeon shook
and my chains fell off.
African American Folk Saying

There is a scriptural account of Paul and Silas in Macedonia where they were locked in chains in prison because Paul had cast a demon out of a damsel that was used for profit in soothsaying by her masters. After being beaten by the

multitude and thrown in jail, the Bible says that *at midnight Paul and Silas prayed, and sang praises unto God: and the prisoners heard them. And suddenly there was a great earthquake, so that the foundations of the prison were shaken: and immediately all the doors were opened, and every one's bands were loosed.*[125] It is interesting to note that that which came from the mouths of Paul and Silas resulted in an action that freed not only them, but everyone else that was imprisoned and that heard them. *All* stocks and fetters were loosed!

Former Senator Robert Kennedy said that American *is a great nation and a strong people. Any who seek to comfort rather than to speak plainly, reassure rather than instruct, promise satisfaction rather than reveal frustration- they deny that greatness and drain that strength. For today as it was in the beginning, it is the truth that makes us free.* There is no country, no entity, no ideal greater than God's Church. It, too, consists of a strong people. But it is an enslaved people, a walled-in people, a people needing to be free. There is a power that we have that can dismantle concrete walls, loose chains from our feet and set us free from the centuries' long injustices that have kept women, and therefore the Church, weak and gaunt. To access this power we must break down the barriers of

ignorance and reeducate ourselves to truth. Then we must speak

that truth so that all who hear it can be free.

Chapter Seventeen
What We See Is What We Want

On November 9, 1989, when Frederik Ramm heard of the dismantling of the Berlin Wall, he grabbed his camera, left college and boarded a plane to get to the wall so that he could witness first hand the history that was evolving that would forever change Germany. Of the many pictures he took, there was one that told a story without words and expressed the frustration and hope that had existed for twenty-eight years. The photograph showed a father with his son, peering through a hole in the wall. For the first time the son was able to see the possibilities in West Germany that were hidden to him throughout his entire life. Though he shared the sky with the West Germans, he could only imagine what it felt like to have the limitless opportunities afforded to those on the other side. In a glimpse he knew that what he saw, he wanted.

"The person who cannot see the ultimate becomes a slave to the immediate."

Women in the Church have stood on the other side and peeked through the proverbial wall of leadership and power and

have seen that which has been kept from us for centuries. Although some might say that it has been hidden, indeed it has not. For the most part it has been paraded before us in full view. For generations we have been taught that it was not for us and that scripture supported a God-instituted caste system where women were innately inferior to men. But though the wall divided us, we shared the same sky and it was something in that sky that fueled our perseverance. And as we stood for years at the wall we gathered enough inner fortitude and outward fearlessness to say: *we see something that we want.*

We See Hope: Unlimited Opportunities

Our first glimpse through the wall has brought us hope. Our first hope is that we can move beyond the trials of the typical. Edwin K. Broadhead knows of our trials and describes them well. Yielding to preachers with lesser gifts but better contacts is typical. Having to be twice as good to get half a chance is typical. Being told to be patient and not pushy is typical. Being blamed for the sins of the world and the downfall of the home is typical. Being judged on gender and not gifts is typical.[126] But we still have hope. Our hope is first in God and in His ability to open the eyes and transform the hearts of

honest men. Our hope is in the Church and in her desire to be the glorified Body that she has been ordained of God to be. Our hope is in each other and our knowing that we have the gifts to minister to God's people according to the call and anointing upon us and the Word that supports our call. Our hope is in our understanding that we are not limited by a view of who we are and a questionable stance on what we should be doing. And though we trust our eyes and like what we see, our hope is not in our sight alone, but in our faith in God's ability to do exceeding abundantly above what we could ever see.

The demands of the time insist that the unlimited opportunities for men to minister be opened to women. The Church is not as effective as it should be because it is stretched to meet those demands with the limited male resources that it is has. It is trying to respond in a typical fashion to atypical needs. We want to be given the chance to meet those needs. Men are not restricted to positions that are determined by their physical strength and brawn as opposed to their brains. They are not even restricted by their gifts. They are not held back from elevation and promotion because they may have family responsibilities. They are not limited by expectations of their personalities and emotional needs. They can do whatever they

want to do according to what they are led by the Spirit of God to do. This leading yields unlimited possibilities for their growth and development as sons of God. We see this and this is what we want.

We See Help: Uncompromising Support

There is camaraderie among the brothers in the Church that is exclusive to even those women who are licensed and ordained preachers. It is not a bond and fellowship based on skill or anointing because it would fall to the giftings of the many women who can hold their own in the exegesis and delivery of the Word of God. It is a club that is gender based and male focused, period. We must acknowledge as women that we support righteous relationships. We believe them to be healthy and important. We do not suggest that they should not exist. We do affirm strongly, however, that they should not be used as unofficial clubs to suppress women and keep them locked out of the circle wherein we know the very opportunities for advancement are passed along. Because we have been locked out for so long, we need your help to get in and we want you to share the keys.

Twenty-nine years ago, a young girl was given the honor

and responsibility of picking up the renowned Dr. Frederick G. Sampson, II, from the airport. She knew that this was one of the world's greatest preachers and was both nervous and excited about her job to usher him in town for his upcoming revival. At sixteen and with a new driver's license, the excitement of this honor proved even more so when he began to talk to her inquisitively about her future. *What do you want to do with your life?*, he asked. She paused, swallowed hard and said, *I want to be a preacher.* She nervously waited for the words that she had heard more than once, but they would never come - *God doesn't call women to preach.* She was amazed with his response: *Enroll in Bishop college and study English. Read the classics. Refrain from placing style above substance.* Instead of being a man who would look at her as a woman out of place, he chose to be a mentor. He gave her advice that would be suitable for any preacher. For over twenty years he would bring her into his church and his pulpit and in the manner in which he served as father to many sons in the gospel, he covered her. In 1997, Ebony Magazine selected her as one of the top 15 female preachers in America. She would go on to serve as the assistant professor of homiletics for ten years at the The Interdenominational Theological Center in Atlanta,

Georgia. The Rev. Dr. Carolyn Ann Knight stands as a living monument to the legacy of this great man. She was blessed to have that rare relationship with a father in the Word that so many women desire. For we see you nurturing your sons and shepherding them with care. We see the financial resources you pour into their ministries. We see you passing your mantles to them, which authenticates their call and validates their work. We see you transfer your identity into your sons and it secures their self-esteem. As your daughters we share a kinship as well and this is what we want.

We See Heart: Unconditional Love and Forgiveness

Over the years we have seen many of our great men of the gospel and our leaders of the Christian community either fall to the pressures of their office or succumb to the spoils of life. It is all too common for the Body of Christ to bury their wounded alive or treat them like animals and shoot them while they are down. But we have seen you pick your brothers up, dust them off and give them another chance. We have seen the ring of forgiveness, the shoes of reconciliation and helped to cook the fatted calf. We have not stood back as the elder brother with protestation of this rightful celebration. For many times we

121

have initiated or led the way in restoring our brothers back to full fellowship. We salute those who have tried to keep the Body of Christ tied with the threads of unity. But this effort should not and cannot be restricted to a relationship between men, it must be a love demonstrated for the entire family. It hurts all of us when one of us has betrayed the principles of the Church. When one is cut we all bleed so it is incumbent upon us to tie the tourniquet together and secure the lifeline of the Body. But all too often we see women sacrificed to save men. We become live organ donors so that their public life and pastoral leadership might be preserved. We have seen you pick your brothers up and carry them to the altar to beg for their restoration. You have stood in the gap to ask that judgment be stayed and their ministries sustained. We applaud your desire to help your brother in need. But as females who are also fallible and prone to the very mistakes that our brothers make, we, too, want your forgiveness and unconditional acceptance. A single mistake on our part should not end our ministry forever. Neither should the mistake of one woman hold all women in suspicion and accusation. When we fall we need you to pick us up, open your wide arms of restoration and then celebrate our return. It is right that you do this for men and this is what we

122

want.

Want Respect for Our Responsibilities

For so long women have worked hard to bring to fruition the vision of great men. Whereas our work has often been acknowledged, it has been minimized by the positions and titles that have been placed upon us. We have not worked for titles and have not scurried for position or placement. However, we have seen the necessity for having both in garnering the proper respect for what we do. Regardless of our public work and assigned responsibilities, we have had to do a song and dance to be licensed as preachers and then have ordination withheld for years at the behest and personal opinion of a single man. The broad brushes of missionary and evangelist have been painted upon all women who minister regardless of their gift or calling. When women are doing the exact same thing that men do, different words are used to describe them so as not to empower them at the same level. We have seen men and women ordained together, but when introduced the woman be called *Evangelist* while the man be referred to as *Reverend.* Women have been called administrative assistants when they have actually been serving as assistant pastors. When we have

tried to question or discuss this we have been accused of playing semantics and of being small-minded. It is probably the very reason why so few women are elevated to the bishopric and considered apostles. It is not that they are not capable of the work or worthy of the call. But there are no other titles to bestow upon them other than what they would be, and it would bring them to an immediate level of equality and respect with their male counterparts.

We Want Authority for Our Assumed Leadership Positions

One of the reasons a proper title is important is because of the authority that it brings. To ask a person to assume responsibility without the proper authority is to set them up for abuse and failure. It is to weaken them and render them ineffective. Typically, when the president of the United States is in the last year of his final term, he is labeled as a lame duck president. Very little is usually accomplished by him because his authority is not at the same level as it was earlier in his term and subsequently the level of respect that he gets, even as president, is less as well. Congress and others are simply waiting for him to move on and out of the White House so that

they can deal with the next occupant.

When women are asked to assume roles and responsibilities without the public acknowledgment by the pastor or leader in authority who in essence transfers their authority with the laying on of hands, they are never regarded in the manner in which they should be and are weakened for their work. It is one of the very reasons why women have to work twice as hard to achieve half as much.

We Must Be What We See

As we demand respect and authority from our brothers it is imperative that we give the same to one another. There are those of us in positions of authority that can serve as mentors to younger women, but we do not. There are women pastors whose churches can financially assist the work of another female in ministry, but they do not. There are women who are respected and regarded enough to open the doors for other women through recommendation and reference, but they do not. Before we can demand these things from others, we must demand it from ourselves. We must share the opportunities that we have with one another. We must never think that having one without having some is ever enough. Whatever help we are able

to give to one another we must give it. We must circle our sisters in support when they fall. But not like lions or ravens in search of fresh meat. In an instant we must run to their aid to pick them up. We cannot afford to sit in judgment and withhold forgiveness from them. We must forgive women as easily as we have been known to forgive our men. We must speak identity into one another, providing confirmation and affirmation to who we are and what we have been called to do. We must move beyond our own limited thinking and experiences to see the unlimited opportunities that exist for all of us. What we want for ourselves we must become for one another. Doing so will hasten our having what we see.

Chapter Eighteen
We Believe We Can Fly

A farmer found a wounded eagle one day out in his field. Not knowing what to do he took it home, and nested it alongside his chickens to keep it safe. He kept the eagle with the chickens where he fed it and took care of it for a long time. One day some visitors to the farm asked the farmer why he had an eagle in his chicken coup. The farmer was surprised at such a question because he had forgotten the bird was an eagle. So the farmer replied that it wasn't an eagle, it was a chicken. The bird had stayed so long that even he had forgotten he was an eagle. He had adjusted to his surrounding and to those around him. He ate what the chickens ate and did what the chickens did. He acted like a chicken with one exception. Though the chickens kept their heads in the ground, he kept looking up in the air. The visitors encouraged the farmer to free the eagle and to see if it would fly. The farmer decided to do that. And when he took the eagle out, the bird, now healed, recovered his identity, returned to his natural environment and began to soar. The farmer stood amazed at the magnificence of his flight and soon accepted the fact that this was an eagle after all. He could

not make an eagle a chicken simply by willing it to be so.

The world is full of chickens and eagles and so is the Body of Christ. Because they have been together so long, many have confused each other and themselves as to who is really who. They have eaten the same bread and meat; drank from the same pitchers of water and milk. They have matriculated in relative comfort within the same confines and many times made adjustments to accommodate the other's needs. Yet despite their concentrated efforts to get along and appear as one, they are not the same. There is something in eagles that make them know that they are limited by their confinements. There is an ache is their bellies to do and be more than what they have been told they are and can do. Even when their leaders are scratching the ground just looking to survive, their eyes are sky bound because they look to soar.

I do not suggest that all women are eagles for indeed they are not. However, it is flawed thinking to suggest that they are all chickens and it is improper to treat them as such. In some cases there was a need for their nurturing and pampering because of the wounds suffered in the very work of the Church. These women were taken and set aside so that healing, growth and maturity could take place. But they have been confined for

too long. They are now healed, and they know they can fly.

> *Hold fast to dreams, For if dreams die*
> *Life is a broken-winged bird*
> *That cannot fly.*
> *Langston Hughes*

The Power of A Vision

History will attest to the fact that environment alone does not determine one's ability nor their ultimate destiny. It may influence it, and it may shape it, but because destiny is a choice driven by heart, passion and vision, it cannot be restricted by confinement or even imprisonment. Within the African American community there are scores of doctors, lawyers, entertainers, athletes, preachers, politicians and teachers who were born into impoverished families and environments that were not conducive to success. But because they saw that a chicken coup could not contain the eagle within them, they envisioned themselves as what they could become and the power of that vision goaded them to its fulfillment. For it really is what we think of ourselves that matters in the end. Our true limits are self-imposed by our imagination, our faith and our fears. A vision and a dream can sustain life and bring hope to the hopeless. A dream fed both the frustration and idealism of Dr. Martin Luther King, Jr. and compelled him to action that

changed the greatest and most powerful nation in the world. A vision of what was right in a sea of injustice and apartheid kept Nelson Mandela in good health and strong mind during a twenty-nine year imprisonment that would serve to prepare him for the presidency. A vision of equality for women propelled through the power of voting drove Elizabeth Cady Stanton and Susan B. Anthony to work tirelessly for something that in the flesh they would never see. But it is not the natural sight that matters most, for Helen Keller said that *the most pathetic person in the world is someone who has sight but no vision.* History is replete with examples of the fearless and the faithful that used the power of a vision and a dream to move them to great heights and to dare to *fight the unbeatable foe, to run where the brave do not go; to right unrightable wrongs and to reach unreachable stars.*

For years, through heartache and tears, women have held within the secret portals of their hearts, a vision of a new Church. It is like the old one in which they have seen themselves en masse as hard workers and contributors to its growth, development and sustenance. But because visions allow you to imagine what is possible beyond the realism of the present, it is a church of inclusion and equality lacking the

gender limitations that hold women and subsequently the entire church in bondage. Our dreams and visions have been a long time coming to fruition, but still we dream. We cannot afford to let them die to time and impatience. Still we dream, for we cannot give up on the potential of a powerful church that will one day represent the true image of Christ's Body and His love for all people. Our visions are the wind beneath our wings. To kill our dreams is to break our wings and then we cannot fly.

It's About Being Tired

As much as we want to make Rosa Parks a heroine and indeed she is, her account of the incident that triggered the Montgomery Bus Boycott, which became one of the greatest movements in African American History, is not at all reflective of someone who was ready to change the country and catapult into her time and place in history. To her, what she did was not about being courageous or heroic. It was more about her being human. *I was just tired!*, she said.

Not all women are visionaries who have plans and dreams for the Church, but they, too, want change. Some would probably say, *we just tired!* They may not be able to express long drawn-out plans to alter the present landscape of

leadership that would ensure the equitable distribution of power. It's not about their desire to pastor or even wanting to get on committees that will determine who has what position and is called by what title. To these ladies whose sweat has soaked their aprons as they have worked hard in kitchens and raised hundreds of thousands of dollars each year, it's about being tired. They are tired of their money being counted but not their opinions. They are tired of being talked about but not being talked to. They are tired of the ignorance of men accepted over the wisdom of women. They want to see change reflected in the way that they are respected. They have seen no hope of this change just happening on its own without any agitation or motivation from others. Weariness and dissatisfaction strikes cacophonous chords of discontentment within them. *We just tired*, they'd probably say. And when you're tired you also cannot fly.

The Force of Our Wings

I must say that I am unapologetic about my vision of us as women and what we want to see in the Lord's Church. I do not believe that it is sin or an act of rebellion for women to desire success or to demand fair treatment at the hands of men, albeit

Christian men. I have no problem with acknowledging that we have eagles who have been pent up too long in a chicken's coup. I realize that our vision of ourselves must supersede any vision that we have of another. For our faith in what we can do and who we are must be the current of air that supports our desire to fly. W.E.B. DuBois said, *there is in this world no such force as the force of a man determined to rise. The human soul cannot be permanently chained.*

I believe we can fly because long before our wings were clipped through the institutionalization of the church, we soared. We served together with men in the early years until the church transformed leadership into the sole prerogative of men.[128] We developed reading programs for the illiterate, feeding programs for the poor neighborhood children, homes for the mentally ill, orphans, homeless women and prison ministries. They were precursors to the Sunday School and Deaconess movements in our country. These were borne out of our compassionate hearts as women and it was only when they became so successful and organized to needing officers and established leadership positions that men became involved and took the reins of leadership and reduced women to subservient roles.[129] The clipping of our wings sent us to the chicken coup

for rehabilitation, but while there we kept looking to the sky and we would see an occasional eagle that kept us convinced that we could still fly.

Today we are fully healed and once again beginning to fly. Women still head most Sunday School departments in churches throughout the country and also have begun reading and tutoring programs for children after school. Without the titles of official recognition, we still run food banks and feeding ministries for the poor and homeless throughout America. And there are those eagles who have flown into the international air waves, like the Bishop Jackie McCullough whose Word Alive ministry provides medical attention to the impoverished in Jamaica. For years Pastor Peggy Moore of Toledo, OH worked diligently in Haiti. Rev. Dr. Jessica Kendall Ingram, now Episcopal Supervisor of of the First Episcopal District and Presiding Prelate Vashti McKenzie of the Tenth Episcopal District, both of the AME Church, have visions to bring health care services to the citizens of South Africa and Africa, respectively. It is the work of these women and many others who make us believe that we can fly.

Of course it is of significance to keep in mind that women never fly alone. One of the more interesting characteristics of

the painted lady butterfly is that it is famous for its extensive mass migrations. The number of painted ladies in a single migration has been estimated at over 300 million.[130] Women will always take others with them. When we are freed to soar, the church is elevated with us. As we are lifted up we pull up other women, but also men and children. To hold us in bondage within unnatural confinements is to limit the entire church. The work of many women within our country's borders as well as the international ministries of Bishop McCullough, Pastor Moore, Rev. Dr. Ingram and Bishop McKenzie all lift up the Body of Christ. Whatever glory that may be given to them is minuscule in comparison to that which will go to God's church. When we spread our wings to fly, we typically make sure that there are others either being carried on them or being protected under them. But it is beneficial to all when we are allowed to fly.

Butterflies are known for their beautiful wings and there are four of them. The development of these wings is essential to the health of the butterfly. They are the largest part of the body. If there is a problem in its emergence from the chrysalis or if the butterfly falls from it, damage will be done to the wings and it may never fly. In some cases it may even die. It is the blood

that is pumped from the abdomen into the veins of the wings that develops them and strengthens them for flight. There are four things that we need to do to ensure our wings have been strengthened to support us for the flight. There are four things that we need to do to ensure our wings have been strengthened to support us for the flight. *1) We need to pray.* There is a transforming power to prayer. We must pray for the Church as never before keeping in mind that our ultimate goal is always for the freedom of the entire Body. Our prayers will unite us. They will uplift us and they will keep us focused on what we have to do. *2) We must participate.* The privilege of being passive and idle is gone. In speaking of the civil rights movement, Rev. Jesse Jackson said, *if you have not committed to the struggle through personal involvement; if you have not marched, have not picketed, you are dangerously adjusted and suffer from a dignity-deficient disorder.* We are not desirous of a movement that will bring notoriety and recognition to a few. We want a grass roots effort of all women and freedom-seeking men who will commit to the struggle through personal involvement. It is dangerous that we have adjusted to our coops. The eagle in us must be free to fly. *3) We must push and prod.* It will be important to have a dialogue with our

136

brothers about church leadership and its exclusion of women. But more than talk there must be some insistence on our part to bring about change. We must push to have women brought into our services as leaders of our revivals and advisors to our planning and building programs. Until complete inclusion has taken place, we must prod our present leadership towards opening doors to more women and then push our women to be prepared to walk through them. *4) We must persevere.* We cannot be discouraged about the lack of support or understanding of those around us when we talk of our visions that we know are God- given and that are destined to change the Church and the world. We cannot give up or give in to the negative influences that want us to leave the comforts of complacency undisturbed. We've been through too much and come too far to turn back. We've already seen what is behind us and we know that the present is not enough. Our hope is in the future and to reach it we must persevere.

Nothing splendid has ever been achieved except by those who dared believe that something inside of them was superior to circumstance. Bruce Barton

It can almost go without saying that regardless of the direction of our flight, we will face turbulent winds. As much

as we know that what we envision for the Church is right and that a more equitable distribution of power is a more righteous stance, we cannot expect that it will be received as such from others. That is all the more reason why our confidence in the eagle in us must be stronger than the gale that faces us. Dr. Dennis Kimbro said that *a human acts, feels, and performs in accordance with what he imagines to be true about himself and his environment.*[131] We can let no farmer, despite the use of eloquence and oratory; convince us that we are chickens. We have been in the wrong environment perhaps, but that environment has not been in us. We have recovered our identity, and will overcome our circumstances because we still believe we can fly.

Chapter Nineteen
Operation Enduring Freedom

America has been forever changed since the tragic events of September 11, 2001. The airplanes that crashed into the World Trade Center, the Pentagon and in Pennsylvania pierced the soul and conscience of our country and forever took away our innocence and naiveté about our security. Its force and impact upon us was so great because as a country we slept through any augury that would have warned us that terrorist threats were impending and danger was imminent. Our government was swift to respond and in a national address three days later, President Bush described us as saying, *this nation is peaceful, but fierce when stirred to anger.* America would not sit idly by and allow our way of life and freedom to be destroyed by cowardly terrorists. Typically when there is a military response to any threat upon our country or allies, there is a name associated with the action taken. In 1991, under the leadership of President George H. Bush, the United States led a multinational invasion of Kuwait and called it Operation Desert Storm. Ten years later, in retaliation of the terrorist attack in New York and Washington, his son, George W. Bush, would take action against Afghanistan that would first be called,

Operation Infinite Justice. This title was challenged because it was offensive to Muslims who believed that only Allah could mete out infinite justice. Therefore it became known as: Operation Enduring Freedom.[132] President Bush said that our goal in this effort would be to *rid the world of evil* and to ensure the American people that our way of life and the freedoms that we enjoy would be forever preserved.

Freedom And Fear Are At War

The day after the president's speech to the joint session of Congress and the Senate (September 20, 2001) the headlines of the San Francisco Chronicle read: *Freedom and Fear are at War.* Freedom is a precious commodity and liberty often requires a battle. If it is not met with demands, it will be held captive by the stronger force that invariably controls it and withheld from all others at a high cost. James Baldwin said, *Freedom is not something that anybody can be given: freedom is something people take and people are as free as they want to be.*[133] In our country, undoubtedly considered the one that enjoys the most freedoms in the entire world, freedom has been restricted to some based on the needs of others. In antiquity, liberty meant national freedom; slavery was considered a

necessary institution of society.[134] So over the years we have seen the meaning of liberty adjusted through the pressure and demand of societal needs. Because the original document that defined our national freedom was seen as bondage to individual needs, changes were demanded so that the civil liberties of certain groups or individuals were not circumvented for the sake of national need. African Americans and women were among those who have had to battle and seek their civil rights to enjoy the freedom that should have been intrinsically theirs. On many fronts these battles have been successful and on some they yet continue. But in each, the first battle that had to be won was the war against the emotional and psychological fear that enslaved them.

We have seen no greater example of this than in the Christian church. The first battle within this entity was against racism. Segregation was considered the norm and still has a stronghold within most churches today. In some denominations, White Christians established churches for African Americans so that they could keep their congregations segregated and still feel as if they had done some great spiritual duty in evangelizing urban neighborhoods. The psychological effect of this was twofold. It made the African Americans indebted to

their Caucasian brothers and sisters and placed them in a position of power and intimidation where the Black Christians were afraid to make decisions or even propagate ideas that would displease their White benefactors. When African Americans eventually rose to a level of confidence where they could fight racism in the Church as well as in America, they found themselves fighting their own fears first. The fight for equality for women in Christendom will also include a battle against our fears. Unfortunately, fear may make this battle appear as if we are against each other. But we are not. Our battle will always be against the fetters that confine us and the dungeons that suppress us. Fear is one such fetter.

We Must Fear...Fear

Before we can effectively win the war against our fears we must expose them and then realign our thinking to overcome them. Mark Twain said that *courage is the resistance to fear, mastery of fear, not the absence of fear.* I do not suggest that we act as if fear is nonexistent, or even that there are not those things that should frighten us. But I do assert that these fears cannot control our decisions or our destiny. We must master them. In the National Prayer Service held on September 14,

2001, the renown Rev. Billy Graham said, *yes our nation has been attacked, buildings destroyed, lives lost, but now we have a choice. Whether to implode and disintegrate emotionally and spiritually as a people and a nation, or whether we choose to become stronger through all of the struggle to rebuild on a solid foundation.*[136] We must remember that we choose to overcome our fears.

Former president Franklin Delano Roosevelt said, *we have nothing to fear but fear itself.* We must fear, fear because it paralyzes and silences during a time when we must be both active and vocal. We must fear, fear because it distorts dreams and vilifies visions that threaten to leave us in a sophistry of softmindedness. To win the war against fear we must be tough-minded. For it is softmindedness that has enslaved us as women. It is the softminded man, according to Rev. Dr. Martin Luther King, Jr., *that always fears change. He feels security in the status quo and he has an almost morbid fear of the new. The softminded person always wants to freeze the moment and hold life in the gripping yoke of sameness. Softmindedness often invades religion. It rejects new truth with a dogmatic passion. Through edicts, inquisitions and excommunications, the church has attempted to prorogue truth and place an impenetrable*

143

stone wall in the path of the truth- seeker.[136]

We Must Fear Stagnancy

Women have been subjugated to the dominance of men for too long. However, it is not simply male leadership that we seek to conquer. To consider doing so would reverse the discrimination that presently exist and do nothing to set aright the Church. Male participation in leadership is both desired and necessary for the Body of Christ to function properly. But we desire to dismantle the gender apartheid that some men have instituted to restrict women to inferior roles within the Church. There are those who will fear any movement or shift of power and who will attempt to make us believe that we should stay as we are. But we must become, if we are not already, dissatisfied with our circumstances and allow this dissatisfaction to propel us to act. To stay in this place is to placate insanity, which has been defined as doing the same thing, the same way and expecting a different result. A stagnant pond smells and kills. We have drunk from this water long enough and are ill at the contaminants that have gotten into our minds and weakened us for our fight. The foulness of stagnancy has made the Body stink. We must clean ourselves up and move on.

Our Plan of Action

Although the terrorists' attacks against us occurred on September 11th the United States did not respond with military action until October 7th, almost a month later. The heinous acts of aggression and murder warranted a speedy response, but in wisdom we developed a plan of war and action to ensure our longevity in battle and our ultimate victory. Throughout this book I have clearly stated the problem that we have as women in the Church. I would be less than responsible if I did not offer a plan to bring about positive change. However, I want more than change. I'm sure that I voice the sentiments of millions of women when I say that we want real, enduring freedom. We want the strongholds destroyed in such a way they can never be replaced or returned to their original state. We want minds changed and hearts transformed by new beliefs and fresh ideas. Oliver Wendell Holmes said that *man's mind, once stretched by a new idea, never regains its original dimension.* We want to inculcate both men and women with the truth that will transform traditional mindsets into think tanks that are unafraid of being forever altered that freedom might reign in the Body of Christ. We want to begin a revolution from which we cannot retreat. Our chrysalis is eaten away and can no longer hold us.

The larva in us is dead. We cannot return to the original ovum that gave us birth. A new birth is in order. We must arm ourselves for battle head on and we cannot retreat.

We Must Be Prepared

We have learned as African Americans that we cannot enter into any endeavor wherein we will be competitive without being prepared. In fact, it is a well-known truth that typically we must be more qualified than our White counterparts. The same can be said about women. The luxury of being ill prepared or even equally as prepared as men does not exist for us. Preparation for ministry and leadership will cost us and we must be ready and willing to pay that price. When our armed forces are preparing for a military operation there are three steps taken before they move. They have a clear strategy for where they are going and what they plan to do. Once confirmed, this plan is not open to debate or change. It is merely studied by those who will carry it out. Secondly, they collect as much intelligence as they can about the opposition. They study their habits and become familiar with their strengths and weaknesses. Thirdly, they put themselves through a physical regiment to make sure that their minds and bodies are ready for the demands of warfare. Our preparation as women in

ministry needs to encompass these same three steps. It will be to no avail that we stand at the door and knock but never prepare ourselves to enter when that door is opened to us. We must begin to write down our visions and have distinct initiatives ready to share with our brothers when our dialogues begin. It will be important for them and other women to see that we are not desirous of bringing about a mere emotional charge to our women but we want to exact change. Preparation must meet opportunity.

We must study: It is past time where we should sit in our pews and lazily receive the Word without studying it for ourselves. We must read and study the Bible as never before. We must read more than what we are told to read. There is no part of the Word that is restrictive to us as women or restricted from us as women. It is in our full knowledge of what God is saying to us that will free us. We must be prepared to answer to the critics, many of whom will be other women, who will question our biblical stance for the freedom and changes that we seek. Before we direct them to the Word we must have studied it ourselves. There are far too many translations available to us to assist in our understanding what is written. A person who will not read is equal to the person who cannot

read. We must read because we can. We must move from being fed by another to eating on our own. Then as pastors and leaders, our studying must take us further into advanced education. There are few seminary programs that are not open to us. And with the advent of online study, the opportunities for us to increase our knowledge and preparation for our roles is multiplied. We can take advantage of this openness and we must prepare. We can no longer count on the Holy Ghost to infuse us with knowledge of a Word that we have not read to give us sermons to which we have given very little thought. Your audience is more intelligent than you think they are and they know when you are not prepared. No amount of rhetoric will convince them of otherwise, despite their being too kind to let you know. The pulpit must become as wise as the pew. It is education that will free us. We must read and study.

We must study our leaders: It is important that we study the spirits and actions of our leaders. We need to know what moves them, motivates them, and inspires them. We need to grasp their vision and know what fuels their fire. To influence their decisions we must understand why those decisions are being made. We need to know what has fed the fears and traditions that are used to bind us and not make mere

148

assumptions about them. We must comprehend what is happening all around us.

We must study ourselves: We need to know and understand what is happening in us as well. Know who you are and what makes you tick. Know your weaknesses and your strengths. Know how far you can go without breaking. You may be tested to that very measure. Without reservation, look at yourself honestly; face your fears - both real and imagined, hidden and obvious. There are others who are studying you and without having had a single conversation, they know you well. Know who you are and what it is that you really believe. *Be sure of your own theological position concerning women in the ministry,* writes Vashti McKenzie. *Be confident, not defensive, about your call to the gospel ministry. Remember that God, not humankind, issues the call to serve.*[137] Embrace the struggles that have made you and use them as fuel to continue fighting.

Our Weapons of Choice: Faith & Trust

When David heard the boastings of Goliath and his blasphemous words against the people of the living God, he took it as a personal challenge and offered to kill him that he might *take away the reproach from Israel.* When King Saul

heard of David's interest in being the man to go up against Goliath he sent for him. After being convinced that even as a youth, David was the man for the job, King Saul dressed him with his own armour to ensure his safety in battle. However, David felt uncomfortable with it and took it all off. Instead he chose to arm himself with what he knew he had tested and tried.[138] Because it was that in which he had faith. Likewise, our weapons for our revolution must be those that we have tried and those that we trust.

We must trust what we know about God: Our studying the Word must not be simply to strengthen our exegetical abilities and our oratory skills, although they are important. It cannot be merely for the attainment of degrees, though that, too, is recommended. However, we must study to reinforce our knowledge of who God is and what He has said about us. Our battle will always begin in our heads and in our minds, because that is the battlefield of Satan. It is likely that we will come against situations and schemes where our education, talents and skills may all fail us. We must have an unstaggering confidence in what we know about God and what we know is right. For it is our knowledge of God that will help us deal with what we have come to learn about the institutionalization of the Church.

It is our knowledge of God that will help us to identify and break down cultural biases that have twisted His Word and taught error as truth. David knew what God had done for him in the past when he was delivered out of the paw of the lion and the paw of the bear. He placed his trust in that knowledge and was victorious.

We must trust each other: Prior to the United States taking any defensive action in Afghanistan, Secretary of Defense, Donald H. Rumsfeld took a five-country tour of the region seeking support and building coalitions for our war attacks. We understood that our success in the war against terrorism that we believed was abetted in Afghanistan required the assistance of neighboring countries. Because of our history and Middle East policies, some of these coalitions would be fragile but we had to trust whatever help we could get. Secretary Rumsfeld said, *we need the assistance of dozens of these Middle East countries if we are to be successful.* However, one president, Islam Karimov of Uzbekistan at first refused to fully cooperate with us stating that *we are not quite ready for this.*[39]

It is imperative that women come together across racial and denominational barriers to win the war against sexism and

151

exclusive leadership practices in the Christian church. Our fight against the evils perpetuated in suppressing women must supplant our loyalty to creeds, traditions and long established cultural practices. We must build coalitions and relationships with one another recognizing that we are inextricably tied through history and experience. What we teach cannot hinder our support of who we are.

In March of 1999, the Rev. Wilma Johnson became the first woman selected as pastor of New Prospect Baptist Church in Detroit. Within weeks of her elevation, the all-male Council of Baptist Pastors of Detroit and Vicinity, a very powerful and influential organization, voted overwhelmingly to drop its traditional ban on women. Upon hearing about their vote, her reaction and response was, *that's wonderful. I'm glad for all of us - women in ministry*[140] Within weeks, they also voted to welcome Rev. Johnson and another woman, a longtime assistant pastor of a Baptist Church, into membership. In May of 1999, the Rev. Dr. Jessica Kendall Ingram, then assistant pastor of the Oak Grove AME Church, held a special service of celebration for women of all faiths to honor Rev. Wilma Johnson. It was a wonderful display of unity and support and it was the right thing to do. Both of these women knew full well

that the elevation of one is the elevation of us all. The relationships and coalitions that we build cannot only help us to reeducate ourselves and build our faith, but through them we can establish movements that can transform the Church, and impact the world. There may be those among us who will say that they *are not quite ready* to join us, but the rest of us must trust each other, build coalitions and work to bring about change.

We must trust who we are and what we do: Whenever one looks to investigate the success of the great visions and large ministries that exist in the United States and in the world, consistently, the role of women is seen. Men, who understand women and do not necessarily consider them as a threat, will entrust them to do certain tasks because they know doing so will yield the results that they need and want. We must trust in ourselves and our gifts the same way that many of them do. We must not ignore our femininity and require that we lose all sense of emotions when we work with one another. We must take advantage of our being nurturers and helpers and applaud it. Our motherly skills are good at building and sustaining strong families and they can be used effectively to build churches. But when we have worked diligently and with

confidence to build great programs or ministries, we should not feel the need to turn them over into the hands of men to be validated. What we see ourselves doing for male-led churches and ministries, we must trust ourselves to do to support those led by women as well.

Our Goal: To Seek Justice, Not Revenge

It is not my desire or intent to suggest or encourage an anti-male movement in the Body of Christ. That would be ludicrous and would serve to only damage the Church and put it in peril. It is my love for the Body that impels me to seek justice for all of us. I do not desire to exact revenge for wrongs of the past or to get back at any one for anything. I am not angry, but I am anxious to see the Body whole. I am not bitter but I demand to be better, for myself, for our daughters, for all of us. There are four things that I encourage sisters to do as we seek justice and enduring freedom for the Church: **Question** - We must look seriously at how we do business at our churches and question the institutionalization that has taken control of the leadership. This is not to say, however, that we must question the intent and integrity of every leader. Many are just as surprised as we are to learn that they are guilty of enforcing a system that

enslaves and demoralizes its women. They have been asleep, along with some of us and have allowed culture and comfort to dictate policy. **Challenge** - The creeds and traditions of church doctrine that have not been revisited since the establishment of the denomination should be challenged to fit the needs of the 21st century church and the dictates of the gifts and anointing that reside therein. **Demand** - Only God's Word should be used as the barometer of measurement for determining how and when women will be used. We must demand that personal preferences be set aside and that gender never be considered as a valid reason to determine or restrict the leadership of the Church. **Support** - we have always supported the visions of men and we ask that they support ours. We must seek their support as full partners in Operation Enduring Freedom. We do not desire to leave them standing on the side as we work to revolutionize the Church. We need to have coalitions with them as well. Their love for the Church demands that they work side by side with us to set us all free.

What Will Drive Our Mission

First of all, we will be driven by a fresh memory of a dark and painful past. It is past, and in some instances still our

present, from which we desire to forge ahead, but it is a memory that we do not choose to forget. We must remember that women were treated like second-class citizens without the basic rights in life. We want to remember that we have worked hard and long but have not received the credit or respect for the accomplishments at our own hands. We must remember that many men in various denominations still do not regard our ordinations. To fail to remember these things and others is to accept them as the norm and to allow them to continue. We cannot forget.

Our mission will also be driven by the hope of what the Church can become. We can see the glorified Church reflected in all of its people and we will not be satisfied until this vision becomes reality. But this church stands at a crossroads of choice; whether to implode and disintegrate emotionally and spiritually or choose to become stronger through all of the people and all of the struggle to rebuild on a solid and equitable foundation. My hope for the Church is that it makes the right choice.

Finally, we are driven by the realization that the battle is not for one or two women. It is about some and all women. There is a passion for freedom in the Body. It is an undeniable

passion to be unquestionably free. We do not want this freedom to be fleeting, short-lived, temporary. We don't want it to be something that we taste but cannot devour. For the sake of all generations to come, we want, we demand a freedom that endures for a Church that will remain until the coming of the Lord.

Chapter Twenty
The Power To Become

Metamorphosis is a Greek word that means *transformation*.

Biologists use this word to describe the extreme changes in form and appearance that occur in lower animals between the growing phase of life and the mature adult phase. Such higher animals as cats, dog, and horses - like human beings - are similar in form and structure when they are born. They differ chiefly in size from the mature adult. These animals exhibit what is known as *direct development*.[141] Throughout this book I have centered our discussion around the metamorphosis of the painted lady butterfly. I have compared our direct *spiritual* development as women to the changes in form of the butterfly and have found the process of the two strikingly similar. I have seen some changes in the Church over the years regarding its attitude on women as leaders, but these changes have often been slow in coming and many have receded as culture and tradition exercised influence in leadership choices. This has left us desiring a metamorphosis or total transformation of the church that does not allow it to return to a previously immature state. I want to see it become the fullness of what God intended through the proper use of all its gifts, regardless of gender.

The Right To Become

Some fundamentalists would say that it is improper to use the word right(s) in reference to women and their roles in the Church. Others would suggest, as does Neal Jones, that *no person, male or female, possesses the right to proclaim God's Word or shepherd God's flock. The office of minister is created by God's call, not an individual's rights. Language about "rights" comes from the political realm and is inappropriate when talking about ordination.*[142] However, when it has been established through prejudicial thinking that God will not or does not call women to preach, then she is disallowed the very privilege of even hearing from God. Through the select interpretation of men, which can be motivated by political and power-based decisions, women are relegated to a level of control and manipulation that forever keeps them undeveloped and immature. We would like to think that politics do not exist in the Church and do not influence the decisions therein. But that thinking would represent a naiveté that is belittling to the Body. We may all agree that politics is not appropriate when talking about ordination, but it is also inappropriate in most spiritual settings. It exists and functions strongly, nonetheless. And mostly it does so to the benefit of men. Edwin K.

Broadhead states that *a part of the forces that bar the door to ministry and service are political. This politicizing of our faith does not bode well for women in ministry.*[143]

Those With Power Have the Right

Can we really comfortably say that no one has a right to preach the Word and mean it? From where do rights come? Are they not entitlements based on one's birth, membership and status? Seemingly this question exists only for those who are not White males because his authority to do anything he chooses is rarely brought into question. For according to culture and accepted traditions, he was born with the right to be and become whatever he desires or dreams. By virtue of his skin color he has been given authority and automatic relationship with the power base that protects his rights. It is only within the Body of Christ and the new birth, in which relationship is not based on race or gender, that we all have inalienable rights. John tells us that *to as many as did receive and welcome Him, He gave the authority (power, privilege, right) to become the children of God, that is, to those who believe in (adhere to, trust in, and rely on) His name.*[144] Our rights as women are tied into our new birth and our power base,

which is in Christ Jesus.

Life In The Son

In a manner similar to the butterfly and it being a solar-powered insect, Christians are Son-dependent and thrive on their relationship with Him. He is our elixir of life. He is also the solution to the *women's problem* in the Church. It is in Him and His example that the answer is found. Instead of our struggling with the teachings of Paul in certain texts (because we typically do not consider *all* that Paul wrote about women) and the culture of the early churches, we would do good to simply look to Christ and His response to women. They had never known a man like Jesus - he never put them down or flattered or patronized them. He had no uneasy male dignity to defend.[145] Women itinerated with Jesus (Luke 8:13)...They were commissioned by him to tell the good news of the resurrection (Luke 24:1-11). The double sexual standard for men and women was firmly rejected by Jesus (Matthew 5:27-28; 19:3-9; John 8:1-11). Not a trace of hierarchical behavior or teaching appears in any of the gospel accounts.[146] Neal Jones says that *the surest Word of God concerning women is not the social prescriptions of ancient cultures, but the incarnate*

161

Word, the only genuinely 'infallible, inerrant Word of God.'

Unless the incarnate Word is one's 'Authoritative answer', one can use Scripture to support, not only sexism, but anti-Semitism, racism, slavery, witch-hunts, inquisitions, and holy wars. Unless it is read with faith in Christ, the Word of God can become the Word of Satan.[147] Jesus must be the criterion by which the Bible is interpreted and on which creeds and practices of the Church are established. He must be at the center of the dialogues that we have on this issue and the votes that are taken to determine the direction of our churches. Though faddish and overused, we really must ask the question, *what would Jesus do?* For the examples that we have of Him in Scripture prove to us that He would not hide behind traditions or the law, as is the custom of some of our major religious leaders today. He would not try to appease the brethren for fear that He would not be accepted in their circles or at their conferences. And He would not use women as a sacrifice to amend the errors and injustices to other men. Our relationship to Jesus must define and determine our relationship to one another. Fritz Guy writes that *the full equality of women and men in ministry is a matter of moral, spiritual and theological integrity, in which we must be guided by the teaching of the*

whole Word of God and the spirit of the gospel of Christ.[148]
The Church as a whole and individuals must return to Christ-centered, Christ-focused living.

The Push To Become

If it has sounded as if there is urgency to our call for change to the Body of Christ it is because there is. Time is short and life is fragile. We do not have the luxury of procrastination and delay. Because the subject of women in ministry is divisive and explosive, many would suggest that we leave it alone and *not push the matter.* For the sake of peace, why not abandon the quest of women for equality? We cannot abandon this quest any more than African Americans could abandon the pursuit, no demand, for the proper exegesis of Scripture that was used to support racism in teaching that they remain faithful slaves in obedience to their masters. Besides, who is at peace? For centuries women have been quiet, but we are not at peace. Our voice and influence have been silenced but we are not at peace. Grenz and Kjesbo write that the *question of women in ministry cannot be abandoned because it is central to the gospel. Positions taken on this issue reveal one's deeper theological understanding or fundamental vision about the nature of God,*

163

the intent of God's program in the world and who we are as the people of God.[149] Simply put, we must push the Church to become like God and we must do it now. The events of our time and the state of the world have created an aperture for the Church to regain its place of prominence and influence. Fear and confusion have people searching for answers that can only be found in God. Once again, people are looking to the Church for comfort and security and we must respond. We must be equipped to respond with a message that speaks to the needs of the people through the integrity of the Word and the real nature of God.

Our Purpose In Becoming

The butterfly has a short life span so it moves quickly to mate and lay eggs to fulfill the purpose of its existence - to reproduce. Our urgency to emerge from the place of our placid pupa is motivated by our need to seed hope into the lives of other women that they might become free. We are clear in our desire to make sure that any and all women who are called into the ministry can be free to respond to God's call and not feel restricted to callous choices of discriminating men. We want to support the successful efforts of women who have been

laboring as pastors, elders and bishops. But we are not satisfied with these successful few. We want more of them, so it is imperative that we reproduce after our kind. Women pastors must look to ordain other women. Female bishops must be ready to consecrate women and welcome them to the apostolate. It is not enough that we stand alone, regardless of how tall we stand and how well we have carried our enormous mantle. Our place in history has been established but our legacy will be prolonged when we reproduce. Am I suggesting that we ordain any female simply because of her gender and our desire to grow in numbers? Absolutely not. We do not desire to have unqualified women in positions in leadership any more than we want to have unqualified men. And the fact that there are many men who are not prepared preachers or effective pastors does not warrant our having women of equal weaknesses. But we must end our reticence to push and promote other women because of our concern of how it will look. The present picture of the Church is not too comely and no one is concerned about how it looks.

Guy says that *we must proceed to ordain women in ministry on the same basis we ordain men: their spiritual experience, their knowledge of Scripture, their competence for*

165

the tasks of ministry, and the fruitfulness of their ministry. We must publicly affirm and fully authorize their ministry in and for the Church. It is the right thing to do, and we must do it without delay. We have waited long enough.[150] We must move expeditiously to ensure that our daughters will not search with longing eyes to see themselves reflected in those with noble callings. We cannot allow the damage to their psyche and belief systems to create in them a fear of who they are and void the hope of who they can become. Those of us who are pregnant with visions for the end-time Church must impart what we see and what we know in other women. We must insist that the great numbers of women who come out of the theological seminaries each year have the same opportunities for service and ministry as do their male counterparts. We must fight the bogus claims that we will force the feminization of the Church. With 80 percent of our churches being female in some instances, it is already a feminine Body. This is generally raised to stir the fears that men will be pushed away and not involve themselves with the Church if women assume leadership positions. Therefore, the comfort of 20% of the Body is considered more important than the justice to 80%, and this should not be. The power to become the glorious Church that

God has ordained has not been a restricted gift to a gender or class of people. To all who have received Him and believed on His name - Black, White, Jew, Gentile, male or female - have been given this power (authority and right) to access relationship with the Father that the promise in mankind might be attained through identity in Him.

Conclusion
An Inheritance Among the Brethren

Never say: "Let well enough alone"...Be discontented. Be dissatisfied. "Sweat and grunt" under present conditions. Be as restless as the tempestuous bellow on the boundless sea. Let your discontent break mountain-high against the wall of prejudice, and swamp it to the very foundation. Then we shall not have to plead for justice nor on bended knee crave mercy: for we shall be men. Ridgely Torrence - The Story of John Hope.[151] Whenever there is a suggestion for real change that involves something so steeped in tradition and comfort, someone will say, *let well enough alone.* I am sure that that cry will come after the release of this book and in the face of our public call for doors to be opened, keys to be shared, walls to be dismantled and stained glass ceilings to be completely shattered. It is a familiar cry to African Americans who marched with Dr. Martin Luther King, Jr. and the early civil rights activists. It is a cry that was heard in South Africa during the years where apartheid reigned and justice suffered. It is a cry of fear. It is a cry of the maladjusted to the misfit thinking of accepted malevolence. It is a cry that will fall on deaf ears. We cannot let well enough alone, because well enough just

ain't good enough anymore. We are discontented and dissatisfied with the present condition of the Church and our restlessness will not let us let well enough alone.

They Speak Right

When Moses was charged by God to divide land among the Israelites according to the male descendants, he was approached by the daughters of Zelophehad whose father had died in the wilderness. Because he had no sons, they would have been left without an inheritance or portion of land on which to live. So they took their plea to Moses to be given the portion that would have gone to their father, in the absence of a son. Moses knew that the Hebrew law gave sons alone the right to inherit. Therefore he took their cause before the Lord who said *the daughters of Zelophehad speak right: thou shalt surely give them a possession of an inheritance among their father's brethren.* [52] As heirs to the promises of Abraham and joint heirs with Christ Jesus, as did the daughters of Zelophehad, with conviction we courageously stand and say, we want an inheritance among the brethren. It is my desire that some men will look upon us and take our cause before God and return to their peers saying *they speak right.* There are those who have

169

already taken the lead in speaking not only to the pain and the promise of women but of stating the need to do what is right to assuage that pain and secure our promise. To acknowledge the pain is good, but it is not enough. To use your influence as men to secure our promise is better and it is also right.

This, Too Is For You

Should the question arise, *why should men help,* let the answer come swiftly: because this is as much about you as it is about us. If our intent is in question then so is your integrity. The issue here is no longer just about women, but about the entire Church and its choices regarding its direction for the future. To help women is to help everybody. To lift us up is to raise the entire Body. To suggest that you will not work with women in leadership is to raise another question: where will you go? If feminization in leadership threatens you and you feel as if you cannot worship with or under women, are you prepared to turn your back on God and worship if the doors are fully opened to women as we suggest? Are you open to men only assemblies? Are you prepared to shut yourselves off to us rather than share your power with us? We hope that you will work with us as we have worked with you. This, too, is for you.

To our Caucasian sisters: although I have primarily spoken from the African American perspective and to our particular struggle, we welcome you to table as well, for this, too, is for you. During the fight for suffrage many White women got their voice in the abolitionist movement. It was then that you saw that a slave is a slave is a slave. Although our words have been essentially directed to the leadership of the African American experience, we are well aware that you, too, sit among congregations that are predominately filled with women, yet dominated by male leadership. You, too, are not free. The debate regarding women's role in Church is done primarily in the White Church and mostly White men write books on the subject. Our men have chosen for the most part to ignore the discussion primarily because we have not required it of them. Yet despite the dialogue among White men, many times it does not include you. And talk about us without the input *of* us, does little to free us. Patricia Gundry describes a Sunday morning Bible Class that she attended as a visitor in a rather *intellectual community of Christians.* The discussion was women's equal participation in the higher echelons of leadership. She sat in horror while the discussion ensued and man after man spoke his opinions about the pros and cons of allowing women a role in

leadership. Not one woman said a word. Not one male commented on the women's silence or asked for their views. Though 50% of the audience consisted of intelligent female adults, they were invisible to the men.[153] The statistics show that your involvement in the leadership of your churches varies little from our own. There is only culture that divides us and it is not enough to stand between our desire to free all of us. This, too, is for you.

To our sisters who do not desire to preach and who have not been called into ministry, this, too, is for you. We are reminded of the words of Booker T. Washington who said, *no race can prosper till it learns that there is as much dignity in tilling afield as in writing a poem.* As I have made references to our work in cleaning auditoriums, washing baptismal garments, preparing communion trays and working in the kitchens of churches I have never intended to suggest that this work has been done without dignity or honor. Everything that we do contributes to the overall success of the entire Body. I do not diminish the work of any; I simply want to make sure that what you do is by your own choosing and not by the design of someone else. I want you to have the choice, for freedom expresses itself in decision. I want your daughters and

granddaughters to feel that they are limited only by what they hear from God and their faith to follow what they have heard. This, too, is for you.

When men and women think about a new question, the first step in progress is taken.[154]

There are several questions that can be asked to begin the steps toward progress in the area of women in ministry. Patricia Gundry asks, *are women fully human?* Gretchen Gaebelein Hill wants to know, *are women fully redeemed?*[155] I would inquire, *if not now...when?* I'm sure that there are other questions that may be on the hearts and lips of those who sincerely desire to begin to dialogue with us and we welcome them being asked. To those who will ask what is it that we want, I begin by sharing the following. We want to *recover* the hearts of women betrayed, broken and battered as they worked in abusive ministries. We want to *redeem* the integrity of the Church, fallen by deceitful and dishonest teachings. We desire to *resurrect* latent power in women, suppressed by the dominance of men. We want to *revolutionize* the Church and the mindset of women, for revolution accelerates evolution. We want to *restore* dignity and honor to women through the proper elevation to position and power. We desire to *reclaim* Christ as

173

the example and authority on the value and equality of women. We *resolve* to fight for freedom, insist on fairness and share the keys of power that the treasures of the Church might be unlocked and revealed to the entire world. We want an inheritance among our brethren, not separate from them. We do not want you to leave us and do not desire to leave you. As we rededicate ourselves to the struggle that will allow us to emerge in maturity and in strength, we hope that you will recommit to standing with us, to joining us in prayer and in purpose that the Church might come forth as pure gold.

Epilogue

Shortly after I began writing this book I knew that it was a God-ordained work that was above and beyond me. My skills were enhanced and my thinking expanded to see a view that was bigger and greater than what I had previously imagined. I became a vessel through which the Holy Spirit spoke to the Church and also to me. I was at times convicted by the words of my own hands and have been changed by them. They have sent me into secret closets in search of the truth of my conscience and I have warred with my own proclivities to tradition and comfort. As a pastor and bishop, I have been faced with instances in which my own thinking demonstrated a leaning toward institutionalization. For this I have repented and refocused myself towards a more equitable distribution of authority and responsibility in the house where I serve. In many ways this book has been life altering. It has served to break down and eliminate all of the remnants of past teachings in a life-long enclave where gender discrimination was taught in error but defended as truth. In my research, I have seen truth redefined and have had to reeducate myself to who women are in light of the now unlimited opportunities afforded them. I

have been stripped and strengthened and together with all women, solidified in the struggle.

About The Author
Bishop Iona E. Locke, D.D., Th.D.

Bishop Iona E. Locke is the presiding prelate of Christ Centered Ministries Assembly based in Southfield, Michigan. She is the founder and pastor of Abyssinia Christ Centered Ministries, a church for all nations, also located in Southfield. As a pastor, preacher, and prophet, she is a much sought out speaker for conferences and revivals throughout the world. Locke was born in Pittsburgh, PA, and is one of nine siblings. At an early age, she came to know Jesus Christ as her Lord and Savior, and according to Acts 2:4, she was baptized with the Holy Spirit. She began her education in the Pittsburgh School System, and later attended Harty's Bible School. Dr. Locke was commissioned by the Lord to further her Christian training. In so doing, she continued on to complete her doctorate in Theology and Divinity Programs in July 1994. It is of greater knowledge to couple education with experience. God has afforded Bishop Locke, throughout the years, the opportunity to train under noted leaders such as: Bishop F.M. Thomas of Pittsburgh, PA, the late Bishop Robert McMurray of Los Angeles, CA and Elder John Lloyd of Bridgeport, CT. Additional training has also come from her father in the gospel, Bishop Norman L. Wagner, former Presiding Prelate of the Pentecostal Assemblies of the World, Inc., Youngstown, Ohio. Having a divine calling from God to preach to all nations, Bishop Locke has extensively traveled the length of these contiguous United States, as well as Antigua, British West Indies, Canada, Italy, West Germany, London, England, the Bahamian Islands, South Africa, Amsterdam, Ireland, Israel

177

and Holland. The anointing to preach the gospel was recognized by the music industry through Intersound Records in 1993. In June, Bishop Locke recorded two compact disc messages released on the Intersound Label. The recordings include "What Kind of Fool Are You?", and "Let's Get It On!" These releases have marked Bishop Locke as the first Pentecostal preacher to have the spoken Word distributed on compact disc. Rave reviews in great demands have and continue to follow the recordings of these sermons. In 1994, after much prayer and fasting, Dr. Iona E. Locke heeded the call from the Lord, to the office of Pastorate. On August 17, 1994, Abyssinia Christ Centered Ministries was birthed. Her Mission Statement includes. To love our brothers and sisters, to give of ourselves, to do all to obey God, to be priestly through Godly relationship. She aims to accomplish with all diligence the wholeness of man, with these commandments and commitments to God and man. She is indeed a vessel called of God to destroy the enemy through the propagation of the Gospel of Jesus Christ. Bishop Iona E. Locke was consecrated as bishop on August 23, 2000, as presiding prelate of Christ Centered Ministries Assembly. She was Former Vice President of International Young People's Union of the Pentecostal Assemblies of the World Former Assistant Pastor of Greater Bethany Community Church, Los Angeles, CA, Former Director of Ecclesiastical Affairs – Mount Calvary Pentecostal Church, Youngstown, OH, Administrative Assistant Emeritus – Perfecting Church, Detroit, MI, Board Member of E.C. Reems International Women's Ministry, Oakland, CA, CEO – Christ Centered Ministries Assembly, Southfield, MI, CEO – Empire Community Development Center, Southfield, MI and much more. She is the co-founder of LeChateau Earl Records.

Bishop Locke is submitted under the apostolic counsel of Bishop Mark Chironna and Bishop Liston Paige, Sr.

Contacting the Author

Dr. Iona E. Locke
Iona Locke Ministries
Abyssinia Christ Centered Ministries
Christ Centered Ministries Assembly
21853 Northwestern Highway
Southfield, MI 48075 www.BishopIonaLocke.com
www.CCMAssembly.org

Footnotes

1. "Painted Lady" World Book Online Americas Edition, http://www.aolsvc.worldbook.aol.com/wbol/wbPage/na/ar/co/724974. August 21,2001
2. John Feltwell, The Natural History of Butterflies, Facts on File Publications, New York, p. 17
3. Ibid, pp. 17-18
4. Brenda Stalcup, Editor, Women's Sufferage, Greenhaven Press, Inc., p.1 1
5. Ibid, p.16
6. Ibid, p.11
7. Ibid, article by Rosalyn Terborg-Penn, Early African-American Suffragists, p. 92
8. Ibid, Brenda Stalcup, p. 16
9. Ibid, p. 17, Excerpted from The Ladies of Seneca Falls, by Miriam Gurko, Simon & Schuster Books, Copyright 1974.
10. Ibid, Brenda Stalcup, p. 17
11. Ibid, p. 18
12. Ibid, p.14
13. Ibid, p.14
14. Floyd Rose, An Idea Whose Time Has Come, p. 14
15. Ex. 3:23-24; Ex. 12:41
16. Charles Trombley, Who Said Women Can't Teach?, Bridge Publishing Inc, South Plainfield, NJ, p. 8
17. Neal Jones, Women's Ordination and the Pretense of Inerrancy, www.baptistnet.com/bwim/ordinationarch.html
18. Ibid
19. Ari L. Goldman, Even For Ordained Women, Church Can Be A Cold Place, New York Times, Sunday, November 29, 1992
20. Charles Trombley, Who Said Women Can't Teach?, Bridge Publishing Inc, South Plainfield, NJ, p.29
21. Ibid, p. 29
22. Ibid, p. 24
23. Robert H. Rowland, I Permit Not A Woman...To Remain Shackled, Lighthouse Publishing Co., Newport, Oregon, p.34
24. Charles Trombley, Who Said Women Can't Teach?, Bridge Publishing Inc., South Plainfield, NJ, p.31
25. Ibid, Babylonian Talmud, Niddah 31b, p. 31
26. Floyd Rose, An Idea Whose Time Has Come, p.50
27. Ibid, p. 29
28. Stanley J. Grenz with Denise Muir Kjesbo, Women In The Church - A Biblical Theology of Women In Ministry, InterVarsity Press, Downers Grove, Illinois, p. 42
29. Edited by James Melvin Washington, A Testament of Hope - The Essential Writings of Martin Luther King, Jr., "Letter From Birmingham City Jail", Harper & Row, Publishers, San Francisco, p. 296
30. Gen. 1:26-28
31. Joel 2:28
32. Acts 2:16-18
33. Isaiah 55:8-9
34. Matthew 19:26

35. Matthew 25:14-30
36. Life Application Bible, King James Version, commentary on Matt. 25:15, p. 1620
37. Ephesians 4:16 AMP
38. Edited by James Melvin Washington, A Testament of Hope - The Essential Writings of Martin Luther King, Jr., "Letter From Birmingham City Jail", Harper & Row, Publishers, San Francisco, p. 290
39. Detroit Free Press, "Artist persuaded that Parks fits park" Associated Press, p.5B, September 7, 2001
40. Webster's New World Dictionary, Third College Edition
41. Prepared by Lynn Wasserman, Living With Multiple Sclerosis, A Practical Guide, The National Multiple Sclerosis Society, p.4
42. Ephesians 4:13
43. Microsoft Encarta Encyclopedia 2000, Caterpillars
44. John Feltwell, The Natural History of Butterflies, New York, NY, Facts on File Publications, p.20
45. Ibid, p.20
46. Microsoft Encarta Encyclopedia 2000, Malnutrition
47. Eugene Peterson, The Message, Matthew 4:4, NavPress Publishing Group
48. Robert H. Rowland, I Permit Not A Woman...To Remain Shackled, Lighthouse Publishing Co., Newport, Oregon, p. 13
49. Ibid, p.14
50. Microsoft Encarta Encyclopedia 2000, Breast-feeding
51. Ibid
52. Ibid
53. 1 Peter 2:2, AMP
54. Hebrews 6:5
55. Psalms 34:8
56. Richelle Thompson, AME Church Gets First Woman Bishop, The Cincinnati Enquirer, July 12, 2000
57. Ari L. Goldman, "Even For Ordained Women, Church Can Be A Cold Place", New York Times, November 29, 1992
58. Richelle Thompson, AME Church Gets First Woman Bishop, The Cincinnati Enquirer, July 12, 2000
59. Proverbs 13:12, NIV
60. Julia A. Boyd, Can I Get A Witness? For Sisters, When The Blues Is More Than a Song, Penquin Putnam Inc., New York, NY
61. Deborah L. Rouse, Lives of Women of Color Create Risk for Depression, www.womensenews.org
62. Michael Carr, The Spiritual Recovery Process of the PTSD Vietnam Veteran, A Psychological Analysis, Wyndham Hall Press, Bristol, IN
63. Bonnidell Clouse & Robert G. Clouse, Editors, Women In Ministry - Four Views; Alvera Mickelsen, There Is Neither Male or Female in Christ, InterVarsity Press, Downers Grove, IL, p.174
64. Genesis 1:27
65. Genesis 1:28
66. Acts 17:28
67. Colossians 2:10
68. Robert S. McGee, The Search For Significance, Rapha Publishing, Houston, Texas
69. Romans 8:37

70. Roland Croucher, Women and Ministry: A Sermon, www.pastornet.net.au/jmm/alpt/alpt0097.htm
71. Ibid
72. Stanley J. Grenz with Denise Muir Kjesbo, Women In The Church - A Biblical Theology of Women In Ministry, InterVarsity Press, Downers Grove, Illinois, p. 45
73. Martin E. Marty, The Pro and Con Book of Religious America, Waco, TX, Word, 1975, p.98
74. Tucker & Liefeld, Daughters of the Church, pp. 252-53
75. Psalms 139:14
76. Life Science Connections, The Skin, www.vilenski.com/science/humanbody/hb_html/skin.html
77. Skin, Hair, and Nails, www.kidshealth.org/parent/general/body_basics/skin_hair_nails.html
78. 1 Corinthians 12:14 AMP
79. Microsoft Encarta Encyclopedia 2000, Skin.
80. Commentary on Matthew 9:17, The Quest Study Bible, NIV, p. 1344, Zondervan Corporation, Grand Rapids, MI
81. Mike Cope and Rubel Shelly, Wineskins, A Purpose Statement, Wineskins Magazine, May 1992
82. Stanley J. Grenz with Denise Muir Kjesbo, Women In The Church - A Biblical Theology of Women In Ministry, InterVarsity Press, Downers Grove, Illinois, p. 37
83. Maria L. Boccia, Hidden History of Women Leaders of the Church, Journal of Biblical Equality, September 1990, p.58
84. Microsoft Encarta Encyclopedia 2000, Hypothermia, Body Temperature
85. Ibid, Metabolism
86. Microsoft Encarta Encyclopedia 2000, Butterfly Life Cycle
87. Lee D. Miller, "Butterfly", World Book Online America's Edition, http://www.aoisvc.worldbook.aol.com/wbol/wbPage/na/ar/co/085160, July 27, 2001
88. John Feltwell, The Natural History of Butterflies, p. 24
89. Matthew M. Douglas, The Lives of Butterflies, The University of Michigan Press, Copyright 1986, p.25
90. Microsoft Encarta Encyclopedia 2000, Butterfly Life Cycle
91. Janice Hayes & Angelo B. Henderson, They outnumber men in the pews but their rise to the pulpit has been slow, The Detroit News, Sunday, August 9, 1992
92. Exodus 2:1-24;3:1-10
93. Esther 1-9
94. 1 Samuel 16:11-13
95. Microsoft Encarta Encyclopedia 2000, Elephant
96. Julius Lester, To Be A Slave, Scholastic Inc., New York, NY, p.p. 126-127
97. Ecclesiastes 3:7
98. Proverbs 18:21
99. Esther 4:13
100. Esther 4:16
101. Stanley J. Grenz with Denise Muir Kjesbo, Women In The Church - A Biblical Theology of Women In Ministry, InterVarsity Press, Downers Grove, Illinois, p.39

185

102.Catherine Clark Rroeger and Richard C. Kroeger, I Suffer Not A Woman, Grand Rapids, Mich.: Baker, 1992, as quoted by Stanley Grenz and Denise Kjesbo in Women In The Church, p. 39

103.Maria L. Boccia, Hidden History of Women Leaders of the Church, Journal of Biblical Equality, September 1990, p.58

104.Stanley J. Grenz with Denise Muir Kjesbo, Women In The Church - A Biblical Theology of Women In Ministry, InterVarsity Press, Downers Grove, Illinois, p.40-41

105.John Beilenson & Heidi Jackson, Voices of Struggle, Voices of Pride, Peter Pauper Press, Inc., White Plains New York, p. 15

106.Teaching History Online, Elizabeth Blackwell, http://www.spartacus.schoolnet.co.uk/USACWblackwell.htm

107.Stanley J. Grenz with Denise Muir Kjesbo, Women In The Church - A Biblical Theology of Women In Ministry, InterVarsity Press, Downers Grove, Illinois, pp. 50-60

108.Janice Hayes & Angelo B. Henderson, They outnumber men in the pews but their rise to the pulpit has been slow, The Detroit News, Sunday, August 9, 1992

109.Microsoft Encarta Encyclopedia 2000, Chick Hatching

110.Richelle Thompson, AME Church Gets First Woman Bishop, The Cincinnati Enquirer, July 12, 2000

111.Jackie Koszczuk, Pelosi becomes 1st female Democratic whip, Detroit Free Press, October 11, 2001

112.Janice Hayes & Angelo B. Henderson, They outnumber men in the pews but their rise to the pulpit has been slow, The Detroit News, Sunday, August 9, 1992

113.Edited by James Melvin Washington, A Testament of Hope - The Essential Writings of Martin Luther King, Jr., "In A Word: Now", Harper & Row, Publishers, San Francisco, p. 167

114.Patricia Gundry, Neither Slave Nor Free, San Francisco: Harper & Row, 1987, pp. vi

115. Stanley Grenz with Denise Muir Ksebo, Women In the Church - A Biblical Theology of Women In Ministry, InterVarsity Press, Downers Grove, Illinois, pp. 45-46

116.Roland Croucher, Women and Ministry: A Sermon, www.pastomet.net.au/jmm/alpt/alpt0097.htm

117.Floyd Rose, An Idea Whose Time Has Come

118. http//www.Encarta.msn.com/encyclopedia

119.Microsoft Encarta Encyclopedia 2000, Berlin Wall

120. John Beilenson & Heidi Jackson, Voices of Struggle, Voices of Pride. Peter Pauper Press, Inc., White Plains, New York, p. 19

121.Lee D. Miller, "Butterfly", World Book Online Americas Edition, http://www.aolsvc.worldbook.aol.com/wbol/wbPage/na/ar/co/085160. October 24, 2001

122.Robert H. Rowland, I Permit Not A Woman...To Remain Shackled, Lighthouse Publishing Co., Newport, Oregon

123.Edwin K. Broadhead, Sharing The Keys, Baptist Women In Ministry, http://www.baptistnet.com/bwim/keysarch.html

124.Kevin Chappell, Ebony Magazine, June 2000, Richard Williams: Venus & Serena's Father Whips The Pros and Makes His Family No. 1 in Tennis

125.Acts 16:25-26

186

126.Edwin K. Broadhead, Baptist Women in Ministry: Sharing The Keys, http://www.baptistnet.com/bwim/keysearch.html

127.John Beilenson & Heidi Jackson, Voices of Struggle, Voices of Pride, Peter Pauper Press, Inc., White Plains New York, p. 39

128.Stanley J. Grenz with Denise Muir Kjesbo, Women In The Church - A Biblical Theology of Women In Ministry, InterVarsity Press, Downers Grove, Illinois, p. 39

129.Ibid

130.Microsoft Encarta Encyclopedia 2000, The Painted Lady

131.Dennis P. Kimbro, What Makes The Great Great, Doubleday, New York, p. 106

132.Arundhati Roy, The Guardian, The algebra of infinite justice, September 29, 2001

133.John Beilenson & Heidi Jackson, Voices of Struggle, Voices of Pride, Peter Pauper Press, Inc., White Plains New York, p.39

134.Microsoft Encarta Encyclopedia 2000, Liberty

135.Carolyn Lochhead, Zachary Coile & Steve Rubenstein, San Francisco Chronicle: Mourning in America, September 15, 2001

136.Martin Luther King, Jr., The Strength to Love, New York: Harper & Row, 1963

137.Vashti McKenzie, Not Without A Struggle, United Church Press, Cleveland, OH, p. 111

138.1 Samuel 17:19-39

139. David E. Sanger and Michael R. Gordon, Preparing for war - US & Britain make late push to forge coalition for combat, New York Times, October 6, 2001

140. David Crumm & Cassandra Spratling, Baptist Ministers Group Accepts Female Colleague, Detroit Free Press, March 10, 1999

141. Charles V. Covell, Jr., "Metamorphosis", World Book Online Americas Edition, http://www.aolsvc.worldbook.aol.com/wbol/wbPage/na/ar/co/085160. November 8, 2001

142. Neal Jones, Women's Ordination and the Pretense of Inerrancy, www.baptistnet.com/bwim/ordinationarch.html

143. Edwin K. Broadhead, Baptist Women in Ministry: Sharing The Keys, http://www.baptistnet.com/bwim/keysearch.html

144. John 1:12, AMP

145. Roland Croucher, Women and Ministry: A Sermon, www.pastomet.net.au/jmm/alpt/alpt0097.htm

146. Roberta Hestenes and Lois Curley, "Scripture and the Ministry of Women", Women and the Ministries of Christ, Pasadena, California: Fuller Theological Seminary, 1979, pp 7-8 as quoted by Roland Croucher, Women and Ministry: A Sermon

147. Neal Jones, Women's Ordination and the Pretense of Inerrancy, www.baptistnet.com/bwim/ordinationarch.html

148. Fritz Guy, The Moral Imperative to Ordain Women in Ministry, www.sdanet:org/atissue/wo/guy.html

149. Stanley J. Grenz with Denise Muir Kjesbo, Women In The Church - A Biblical Theology of Women In Ministry, InterVarsity Press, Downers Grove, Illinois, p. 142

150. Fritz Guy, The Moral Imperative to Ordain Women in Ministry, www.sdanet:org/atissue/wo/guy.html

151. John Beilenson & Heidi Jackson, Voices of Struggle, Voices of Pride, Peter Pauper Press, Inc., White Plains New York, p.40
152. Numbers 27:1-7
153. Alvera Mickelsen, Editor, Women, Authority & The Bible, InterVarsity Press, Downers Grove, IL,1986, p. 15
154. Brenda Stalcup, Editor, Women's Sufferage, Greenhaven Press, Inc., p. 21
155. Alvera Mickelsen, Editor, Women, Authority & The Bible, InterVarsity Press, Downers Grove, IL, 1986